T0337754

-cool- ILLUSTRATION

Editor, concept, and project director
Josep María Minguet

Co-author
Carolina Amell

Art director, design and layout
Carolina Amell
(Monsa Publications)

Cover design
Carolina Amell
(Monsa Publications)

INSTITUTO MONSA DE EDICIONES
Gravina 43 (08930)
Sant Adrià de Besòs
Barcelona (Spain)
Tlf. +34 93 381 00 50
www.monsa.com
monsa@monsa.com

Visit our official online store!
www.monsashop.com

Follow us on facebook!
facebook.com/monsashop

ISBN: 978-84-15829-98-0
D.L. B 19845-2015
Printed by Grafo

Cover Image by
RICARDO CAVOLO

Back-cover Image by
ESRA RØISE

-cool-
ILLUSTRATION

BY CAROLINA AMELL

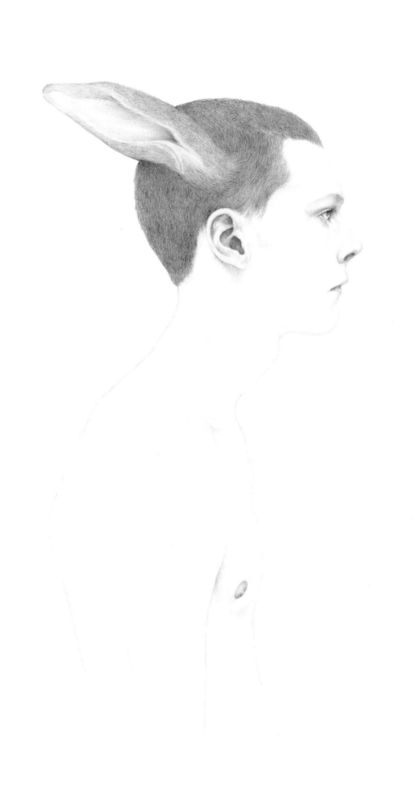

INTRO

"Cool" is something fresh, new, which transmits modernity. This sensation which we are hoping you to find by submerging yourself in this book.

If you are looking for inspiration, here we will be able to see marvellous creations by artists like Ricardo Cavolo, María Herreros, Paula Bonet, Dilka Bear, Denise Nestor, etc.

These are works full of avant-garde, communication and creativity, of very different technics and themes, all sharing the common nexus of being able to speak and transmit on their own. Seeing them, we live their stories without the need for text or description.

"Cool Illustration", a book to enjoy!

"Cool" es algo fresco, nuevo, que transmite modernidad. Esta es la sensación que hemos intentado que encontréis al sumergiros en este libro.

Si buscáis inspiración, aquí podréis apreciar las maravillosas creaciones de artistas como Ricardo Cavolo, María Herreros, Paula Bonet, Dilka Bear, Denise Nestor, etc.

Obras llenas de vanguardia, expresividad y creatividad, de técnicas y temáticas muy diferentes, y con el nexo en común de que todas ellas hablan y transmiten por si mismas. Al verlas, seremos capaces de vivir sus historias sin necesidad de texto ni descripción.

"Cool Illustration", un libro para disfrutar!

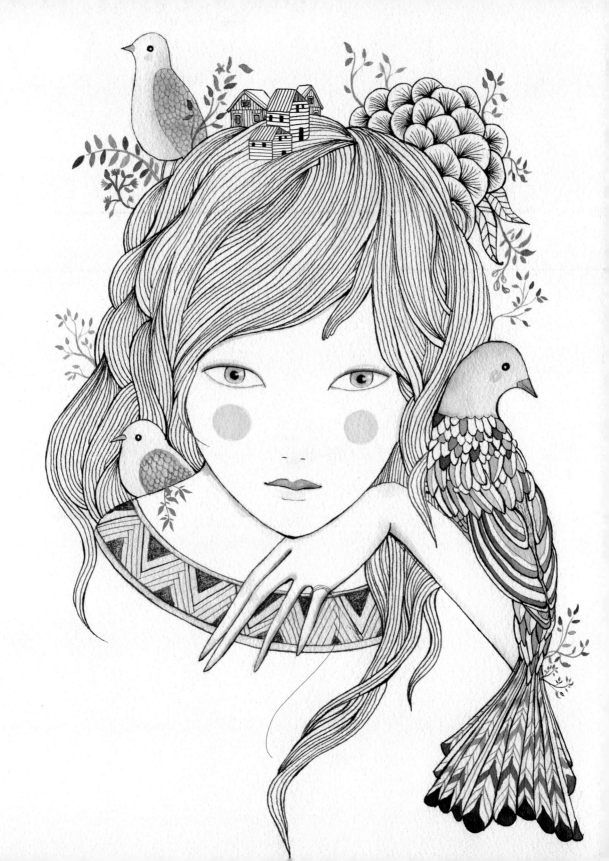

INDEX

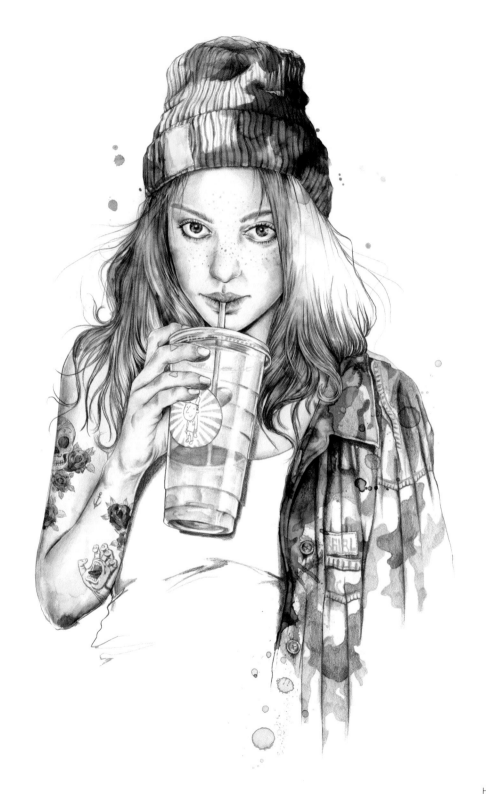

Homegurl

ESRA RØISE

www.esraroise.com

Esra Røise is a Norwegian illustrator with roots in fashion illustration. She has always loved the preciseness of the pencil and the unpredictability and possibilities of watercolor and ink. She enjoys the juxtaposition of different mediums, particularly the analogue and digital combined, and most of her elegant and playful works are a combination of the two. Esra draws inspiration mainly from the fashion world, music and popular culture.

Her works can be seen worldwide, and selected clients include: VOGUE, Stella McCartney, Farfetch, Nylon magazine, Wallpaper*, Estée Lauder, VICE, LEVI'S and Miss Selfridge to name a few.

Agency representation by ByHands (NO) and Unit (NL)

Esra Røise es una ilustradora noruega que se inició con la ilustración de moda. Siempre le ha gustado la precisión del lápiz y la imprevisibilidad y el potencial de la acuarela y la tinta. Disfruta con la yuxtaposición de distintas técnicas, en concreto la mezcla de lo analógico y lo digital, y la mayoría de sus elegantes y divertidas obras son una combinación de ambas. Esra se inspira principalmente en el mundo de la moda, la música y la cultura popular.

Sus trabajos pueden verse por todo el mundo y algunos de sus clientes más selectos son Vogue, Stella McCartney, Farfetch, las revistas Nylon y Wallpaper*, Estée Lauder, Vice, Levi's y Miss Selfridge, solo por nombrar unos pocos.

Agencia de representación por ByHands (NO) and Unit (NL)

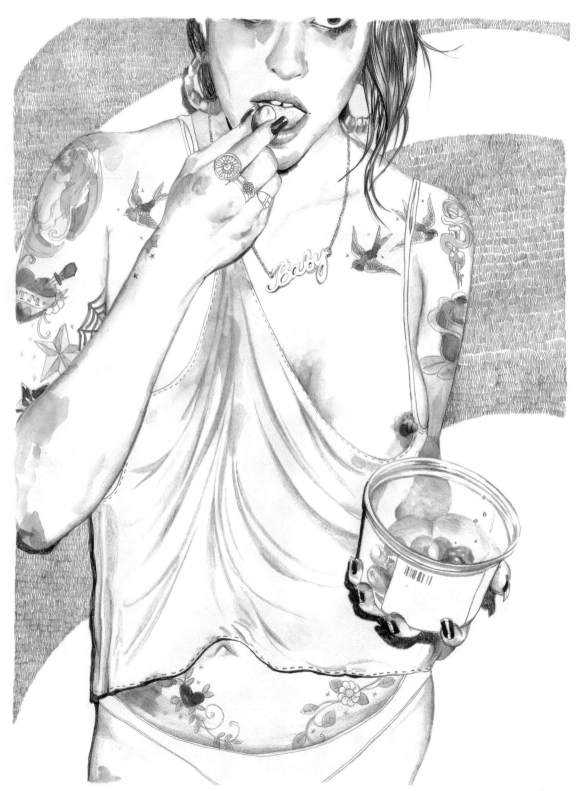

Sugar 4

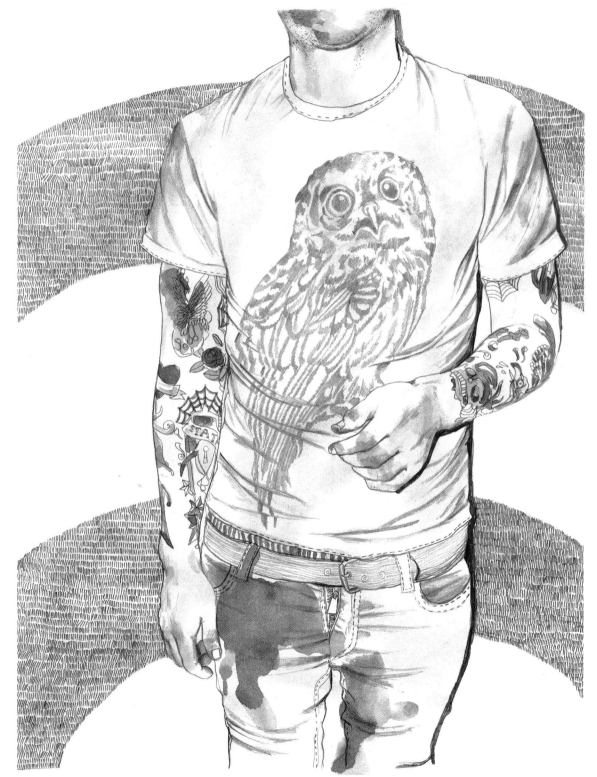

Sugar 1

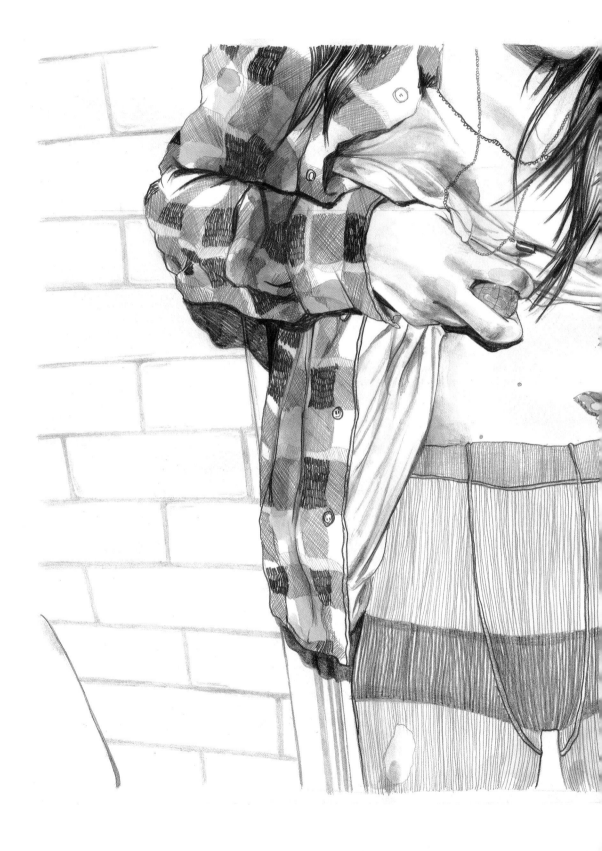

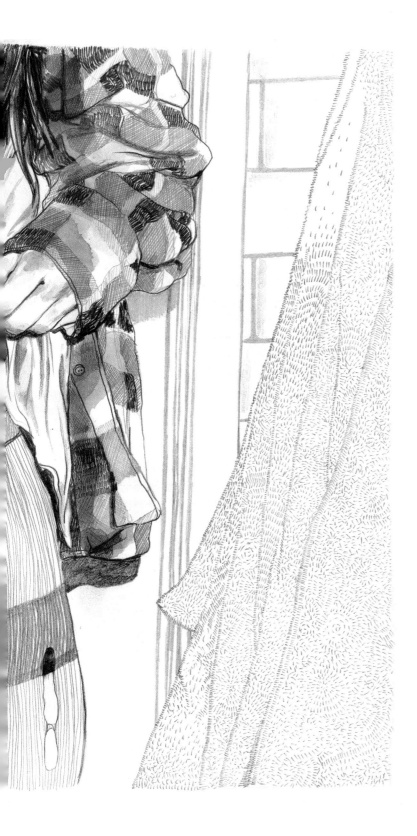

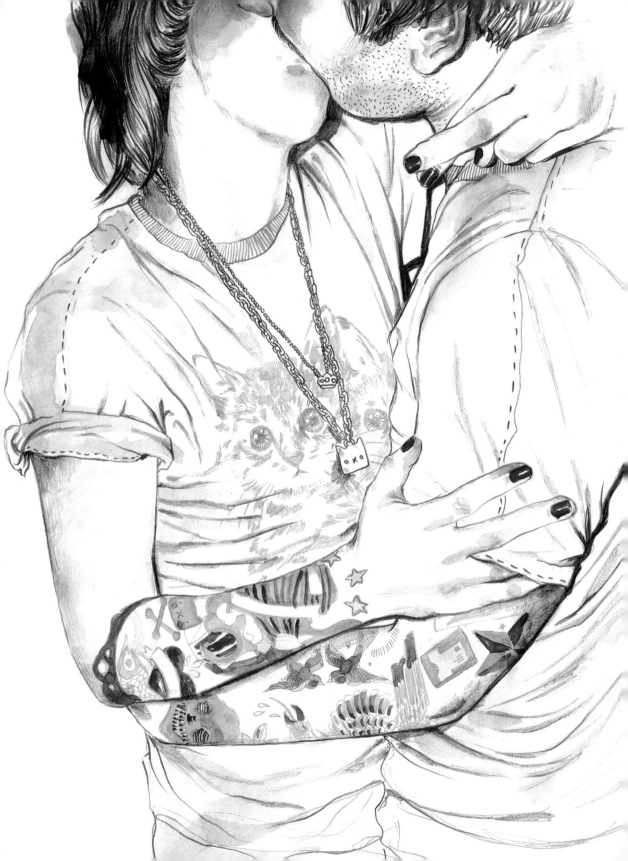

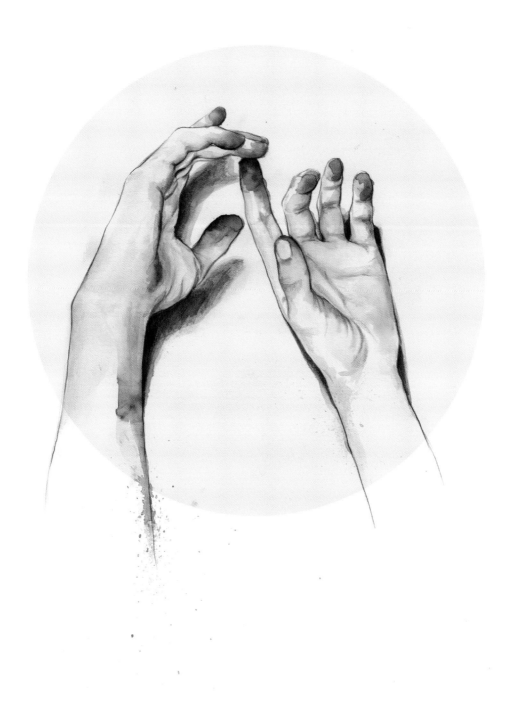

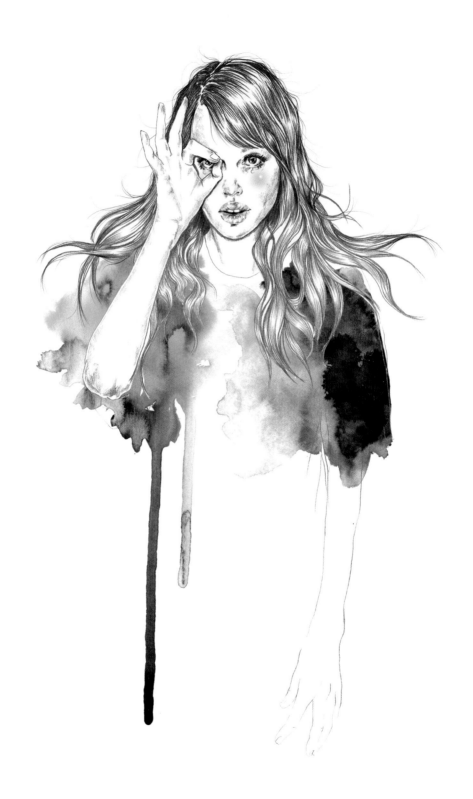

Hello

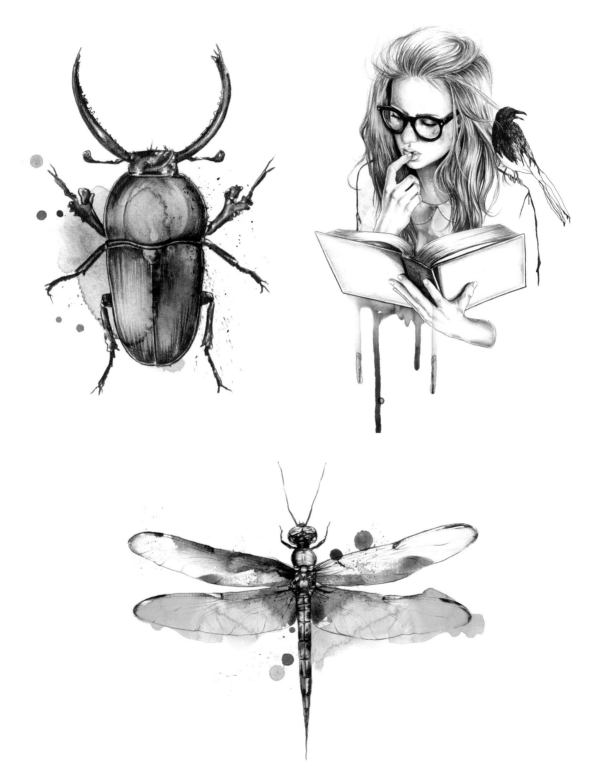

on top: Bug + Book worm // Dragon fly

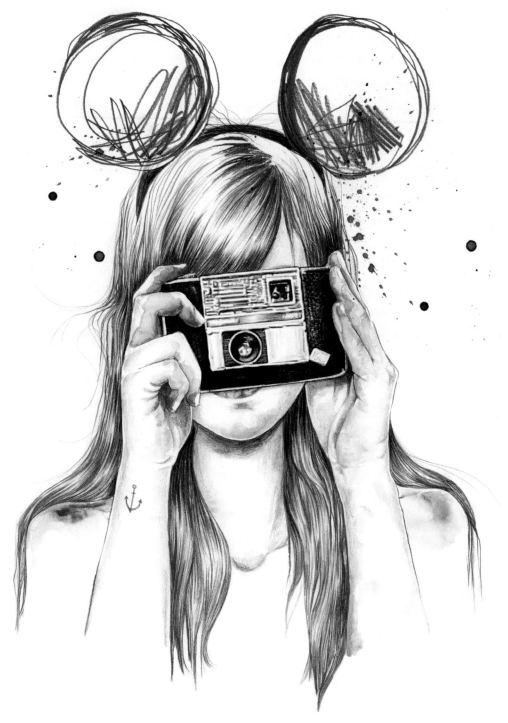

Camera face // right: Now is the only time

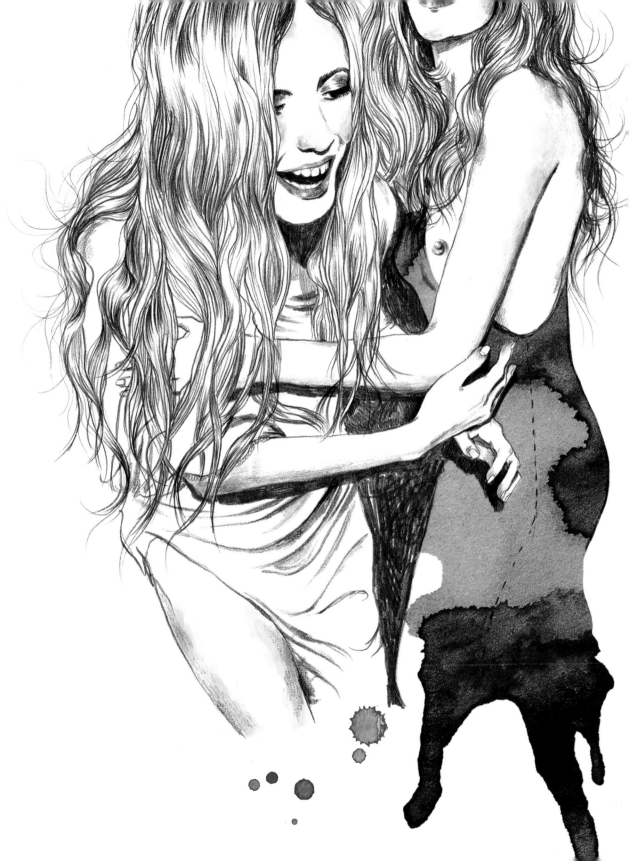

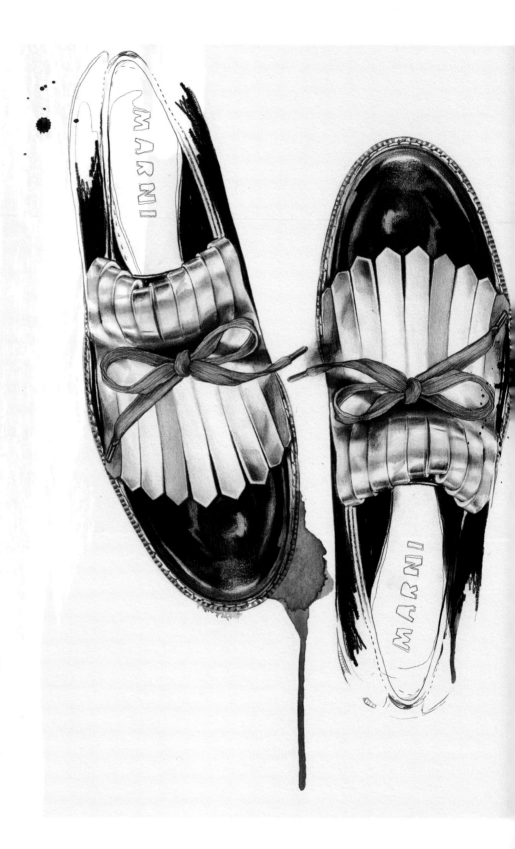

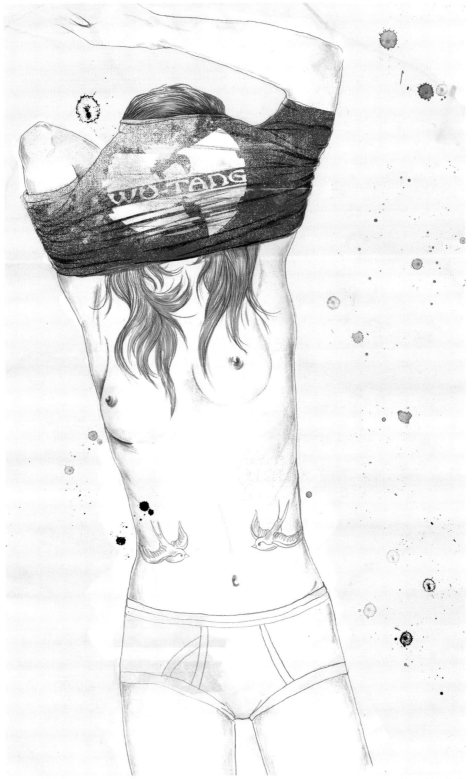

Mami brougues

Ainnuthintofkwit

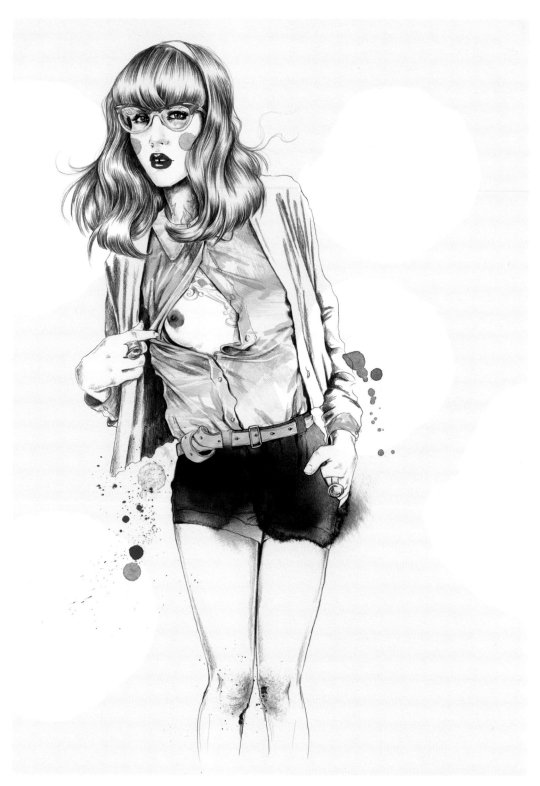

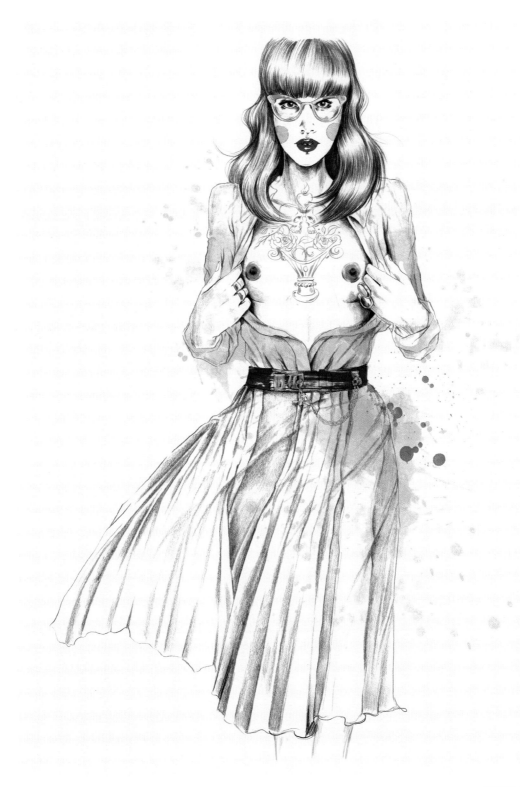

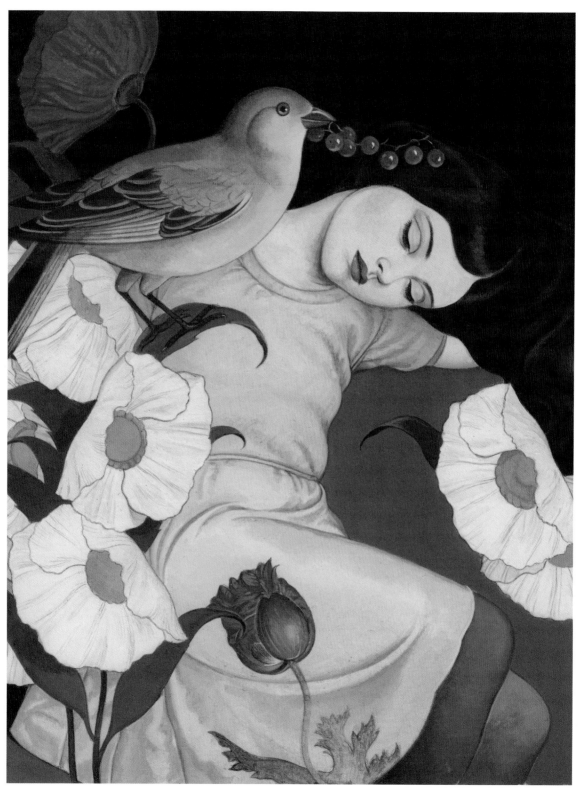

L'Anniversaire

PIERRE MORNET

www.pierremornet.com

Pierre Mornet was born in 1972 in Paris. He studied graphic design at the ESAG Penninghen school, and presented his first exhibition in 1994. He started working in illustration shortly after.

He has published four children books and designed many book covers (Penguin, Random House, Gentosha, Tokuma Shoten, Gallimard, Salani…).

His work appears in the press (Vogue Japan, The New Yorker, The New York Times, The Washington Post, Vanity Fair, Le Monde…), media and advertising, and is regularly showcased in art galleries.
In 2006 he designed the international ad campaign and packaging for a special edition of the perfume FLOWERBYKENZO.

On-going since 2009, Pierre has also been the poster designer for the productions of the Lille Opera House.
His work has been chosen by Joyce Carol Oates for the new prints of her books by HarperCollins.
In 2013 he collaborated with Miuccia Prada for Womenswear SS14 show and stores.

His paintings were also used by InStyle magazine for a shooting with Sarah Jessica Parker.

He is represented in the USA by Marlena Agency.
www.marlenaagency.com

Pierre Mornet nació en 1972 en París. Estudió Diseño Gráfico en la escuela superior ESAG Penninghen e hizo su primera exposición en 1994. Poco después, empezó a trabajar en el mundo de la ilustración.

Ha publicado cuatro libros infantiles y ha diseñado muchas cubiertas de libros (Penguin, Random House, Gentosha, Tokuma Shoten, Gallimard, Salani…).

Sus trabajos se publican en prensa (Vogue Japan, The New Yorker, The New York Times, The Washington Post, Vanity Fair, Le Monde…), en los medios de comunicación y en publicidad, y suelen exhibirse en galerías de arte.
En 2006 diseñó la campaña de publicidad internacional y el envase para una edición especial del perfume FLOWERBYKENZO.

Desde 2009, Pierre también ha diseñado los carteles para las representaciones de la Ópera de Lille.
Joyce Carol Oates ha elegido sus trabajos para las reediciones de sus libros que ha publicado la editorial HarperCollins.
En 2013 colaboró con Miuccia Prada para el desfile de moda de la campaña femenina primavera-verano 2014 y sus tiendas.

La revista InStyle también utilizó sus cuadros para una sesión de fotos con Sarah Jessica Parker.

Está representado en los EE.UU. por la Agencia de Marlena.
www.marlenaagency.com

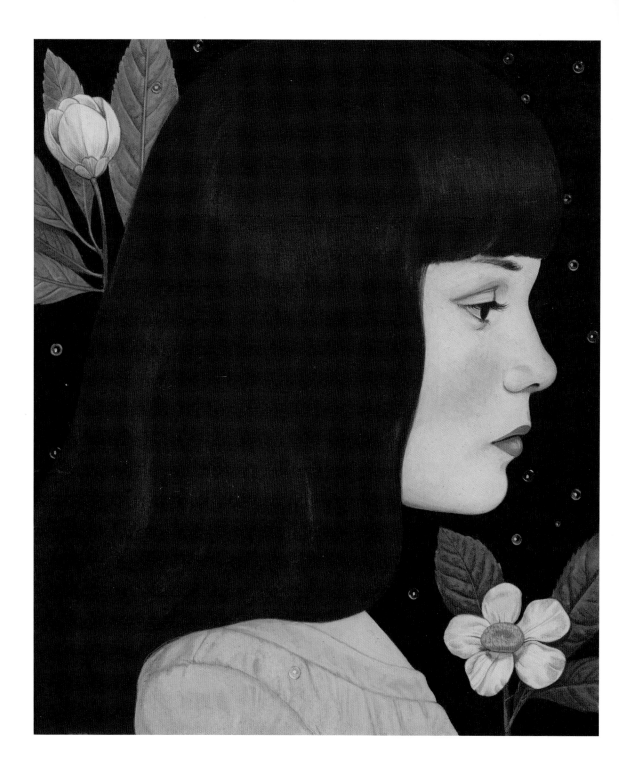

La pluie qui tombe

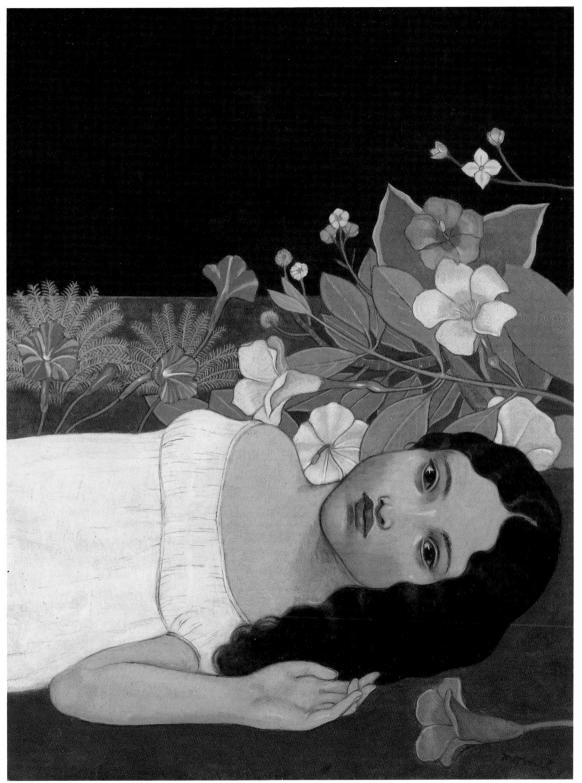

Wide Sargasso Sea

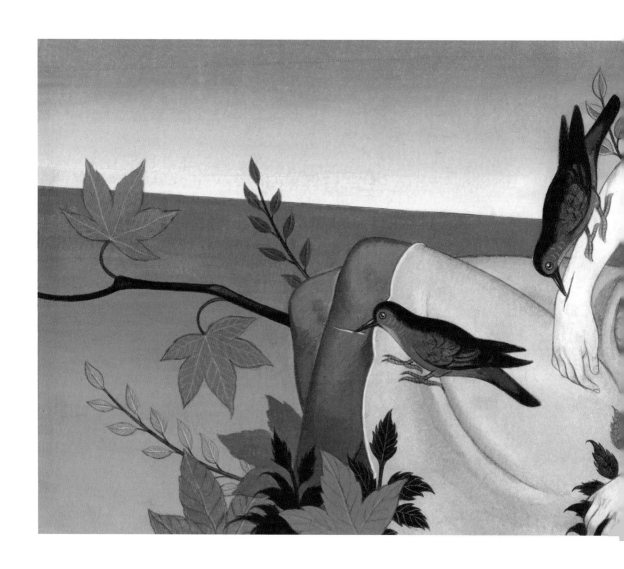

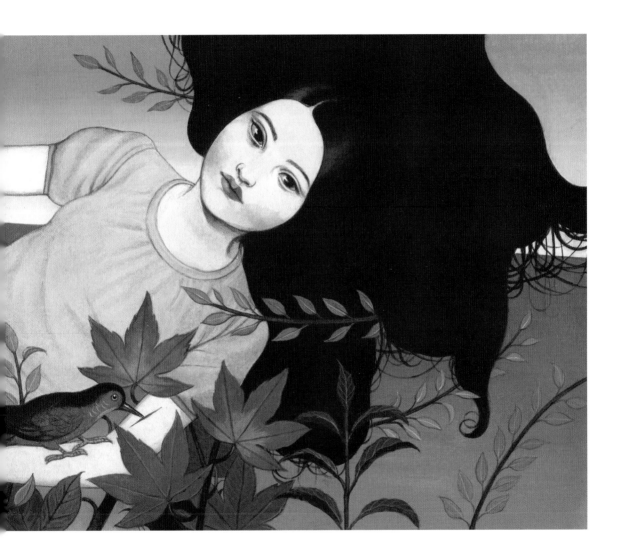

A lonely girl has gone

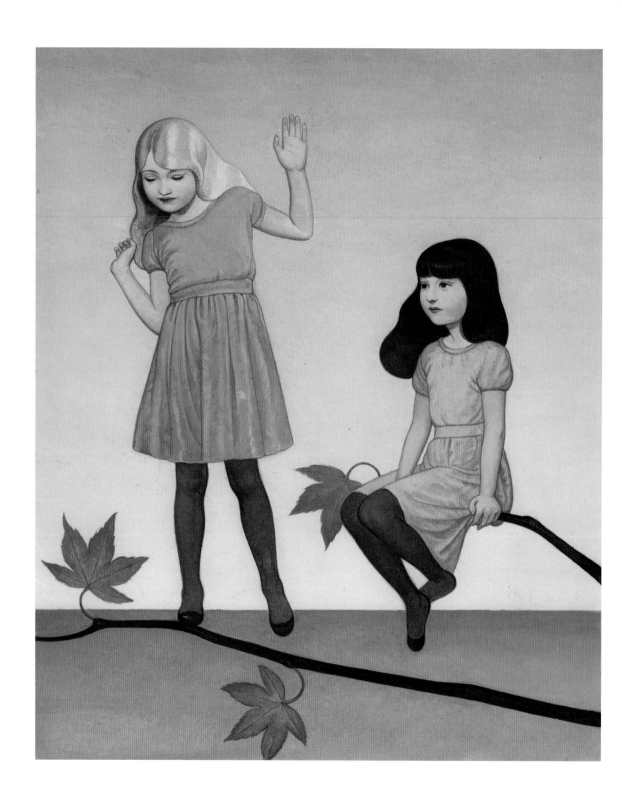

Deux filles

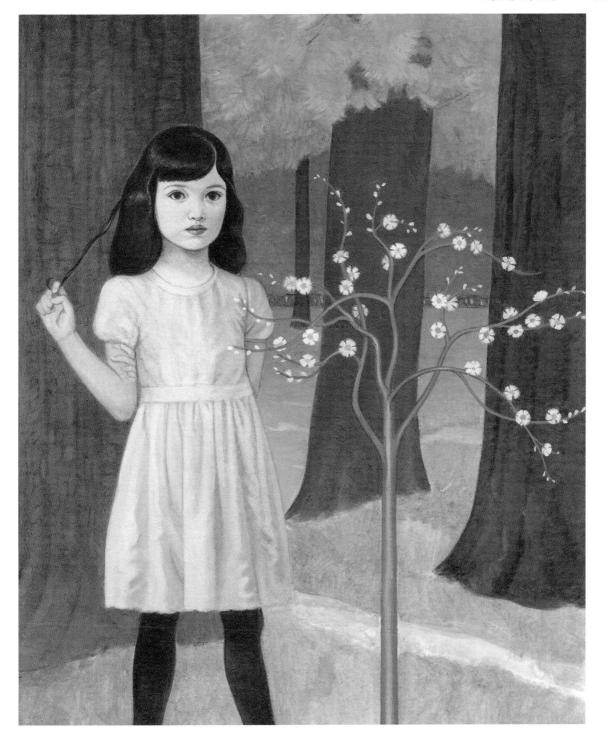

La robe bleue

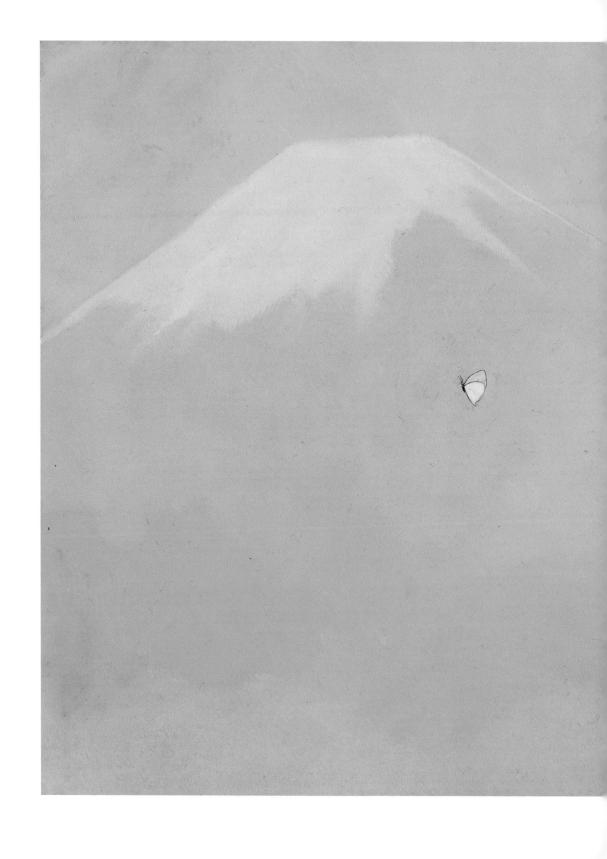

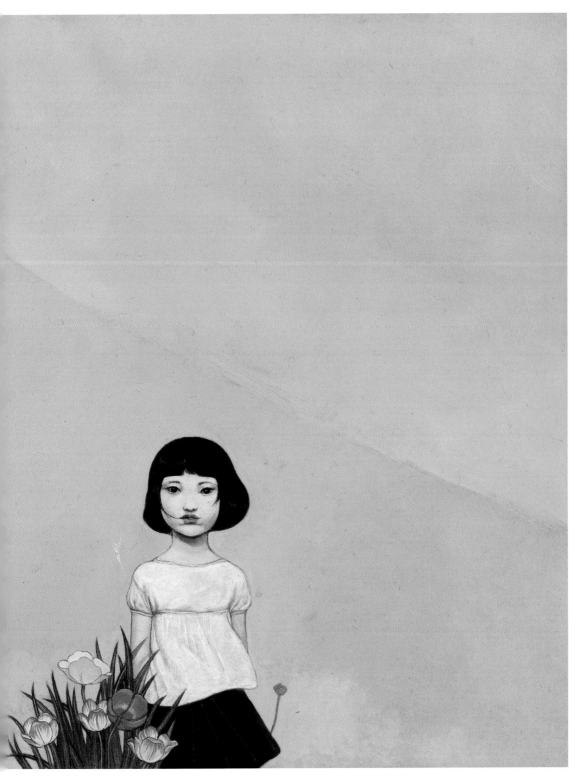

Mont Fuji

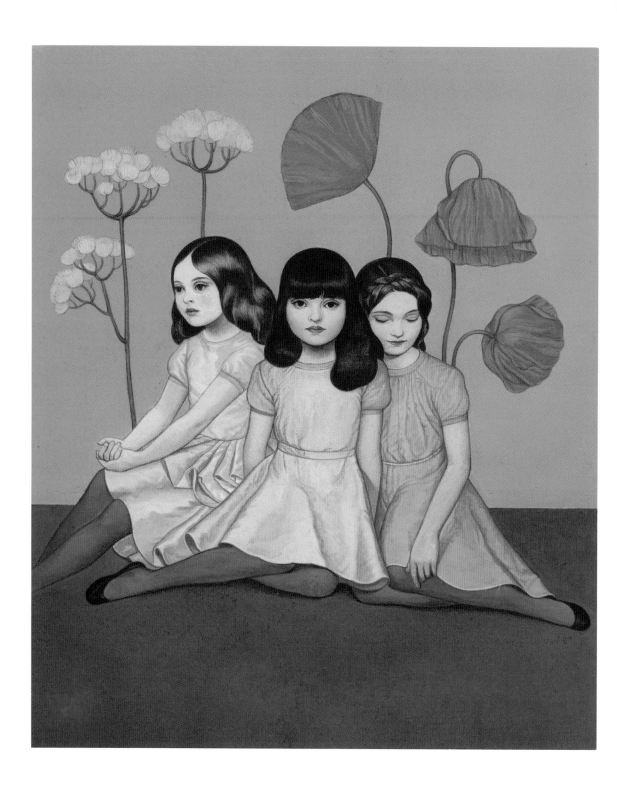

Trois filles

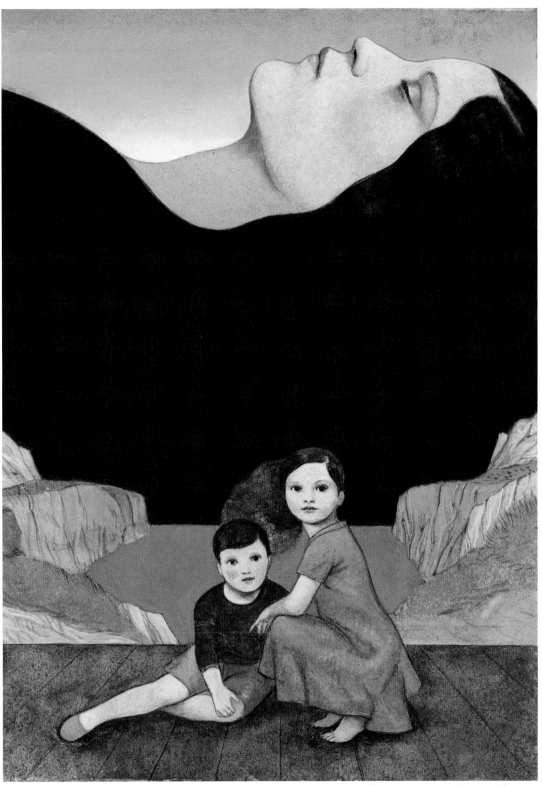

Mother & Children // **next page:** Choses qui font peur

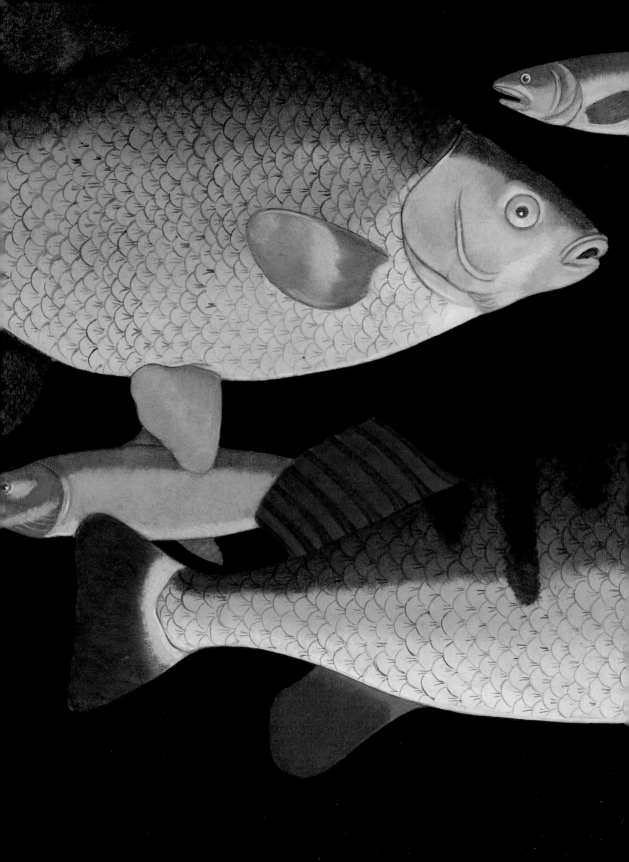

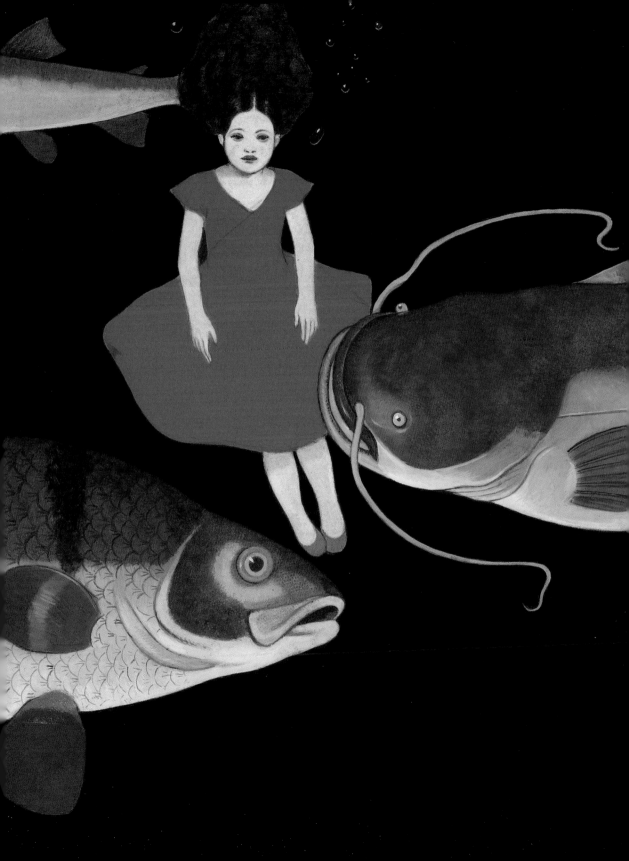

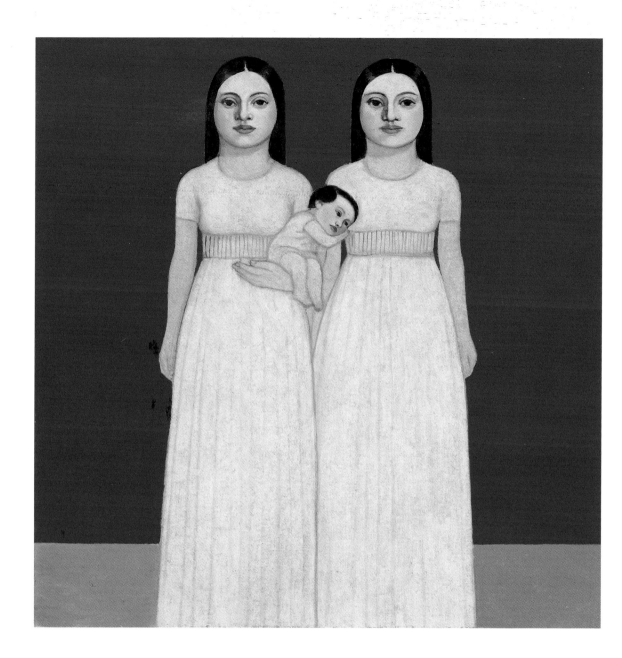

Jumelles

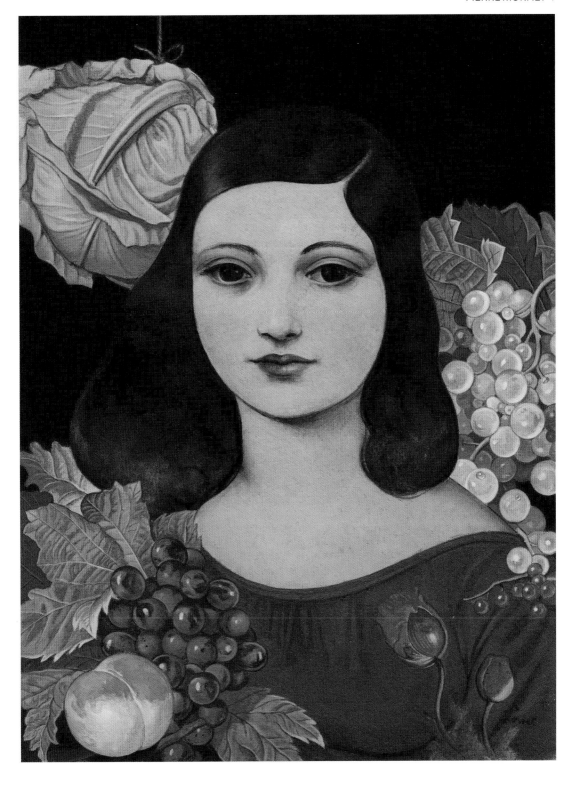

Les fruits

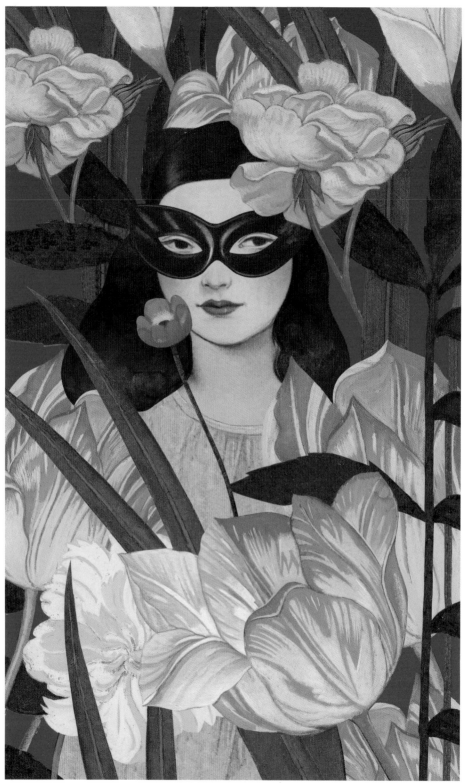

Guilty Pleasures

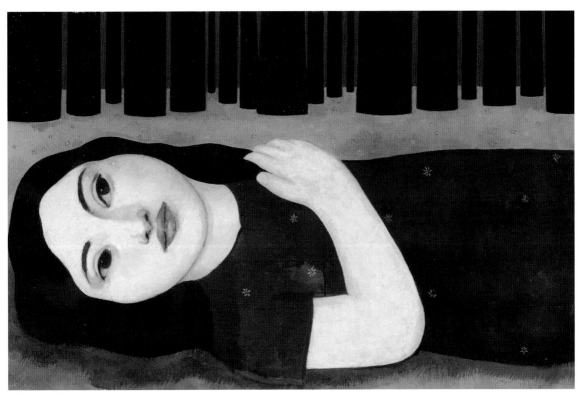

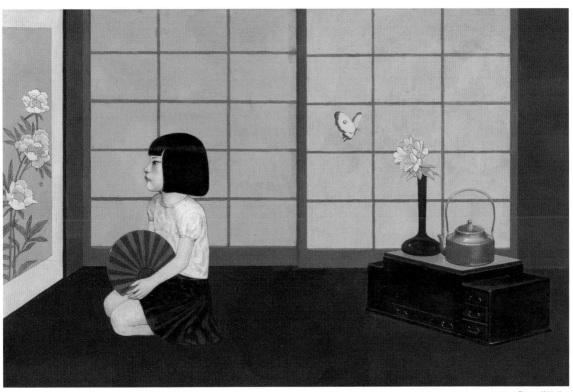

on top: Puce // Keiko

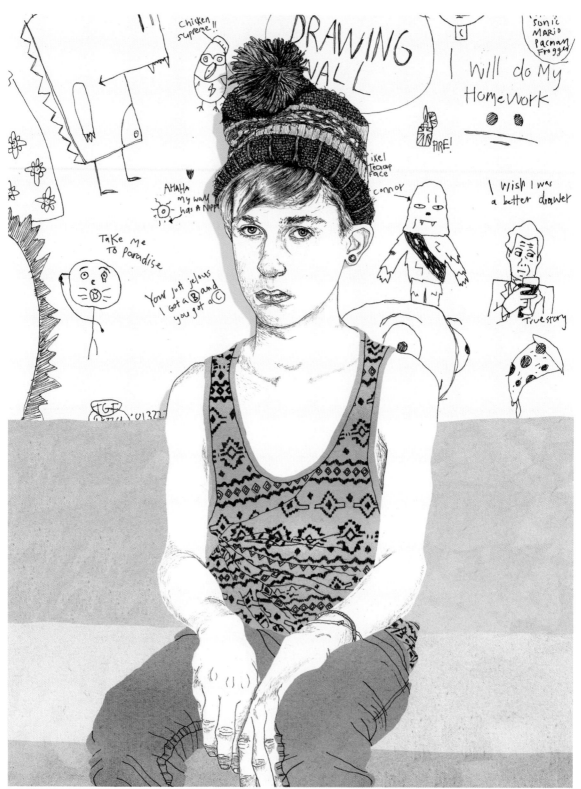

Boy in a Hat

ADAM CRUFT

www.adamcruft.com

Adam Cruft is a freelance illustrator born, raised and based in London.

His father is an illustrator and when he was small and his father used to work from home, Adam would keenly sit and watch him. His father would be at one end of the desk working away, while Adam would be at the other end drawing/scribbling on scraps of paper given to him. He would draw his cartoon idols from memory and any other interesting material that he could find in the reference books scattered around his father's studio.

Adam has continued to draw since then.

His working process starts with him picturing a visual image in his head. He's particularly fond of Paul Gauguin's quote, "I shut my eyes in order to see". Even if its a straight-up portrait commission he has to first visualise it in his mind's eye before he puts pen to paper; it gives him that little bit of direction. He may do one or two roughs and then go straight into the finished piece 'alla prima' style. He prefers to draw with pen straight onto the paper without any or very limited plotting beforehand. He finds this helps to make his work less contrived and less tentative, thus adding to the character of the piece.

Adam Cruft es un ilustrador autónomo nacido, criado y afincado en Londres.

Su padre es ilustrador y siempre ha trabajado en casa. Adam se sentaba entusiasmado a observarlo, su padre se colocaba en un extremo del escritorio, mientras que Adam se ponía en el otro y hacía garabatos en trozos de papel que le daba. Dibujaba a sus ídolos de los dibujos animados, o personajes interesantes que encontraba en los libros de referencia que había por el estudio de su padre.

Adam no ha dejado de dibujar desde entonces.

Su proceso de trabajo empieza con una imagen visual en su cabeza. Le gusta mucho la cita de Paul Gauguin que dice «Yo cierro los ojos para ver». Incluso si le encargan directamente un retrato, él tiene que imaginárselo antes de apoyar el bolígrafo en el papel; es lo que le orienta un poco. Primero hace un par o tres de bocetos y después se pone directamente con la pieza. Él prefiere dibujar con bolígrafo directamente sobre el papel sin hacer ningún o muy pocos trazados antes. Considera que esto ayuda a que su trabajo sea menos artificial y experimental, lo cual añade carácter a la obra.

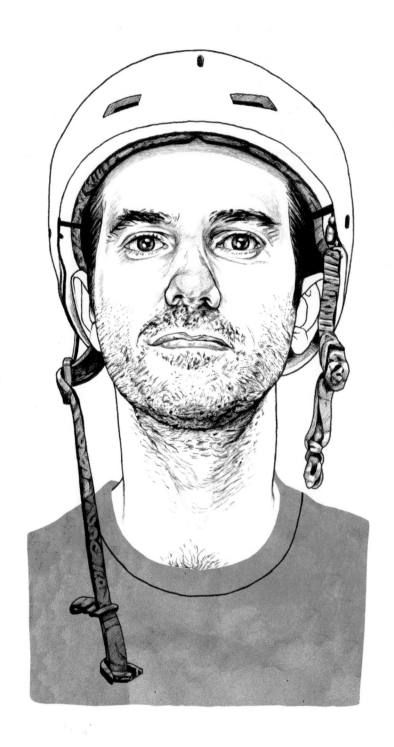

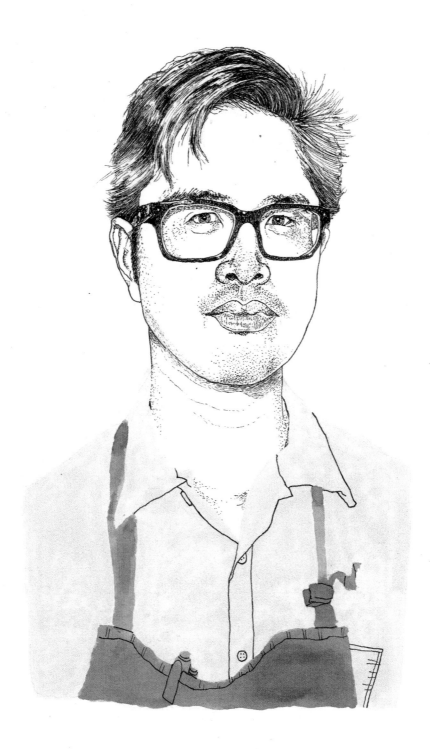

Chef, Jeff Claudio for Toronto Life

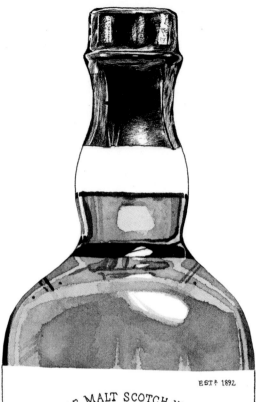

EST<u>D</u> 1892

SINGLE MALT SCOTCH WHISKY

Distilled at

THE BALVENIE®

Distillery Banffshire
SCOTLAND

SINGLE BARREL®

SINGLE MALT SCOTCH WHISKY
FROM A SINGLE CASK

AGED **15** YEARS

| BOTTLING DATE | 24/10/2007 | CASK NUMBER | 753 |
| IN CASK DATE | 04/09/1992 | BOTTLE NUMBER | 243 |

CAREFULLY SELECTED BY
THE BALVENIE MALT MASTER · David c Stewart

THE BALVENIE DISTILLERY C?
DUFFTOWN, BANFFSHIRE
SCOTLAND AB55 4BB

70cl e 47.8%vol

Jonathan Saunders for Esquire // **left:** Balvenie Bottle

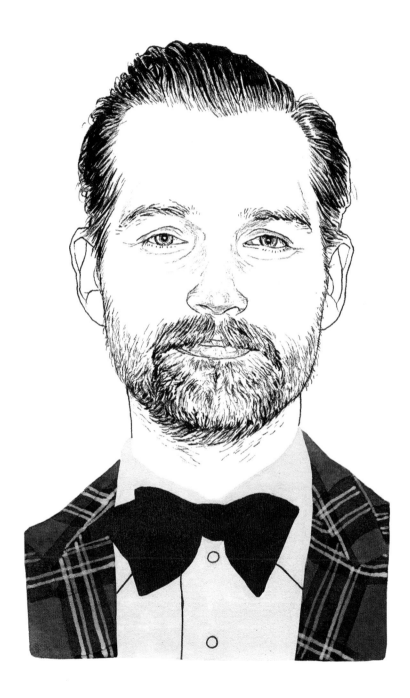

Patrick Grant for Esquire // **left:** Wylie Dufresne

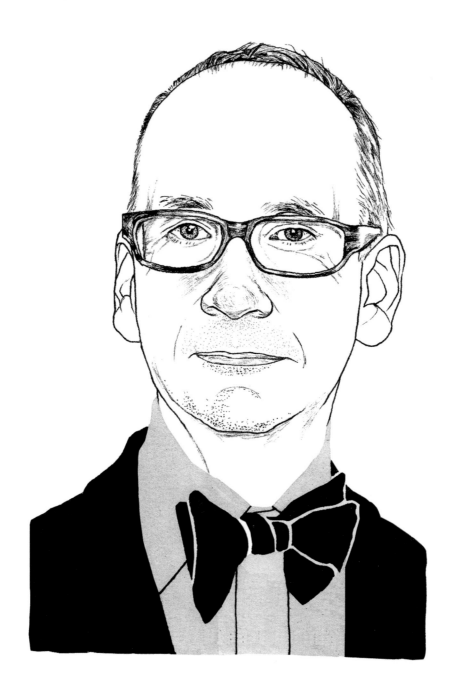

Richard James for Esquire

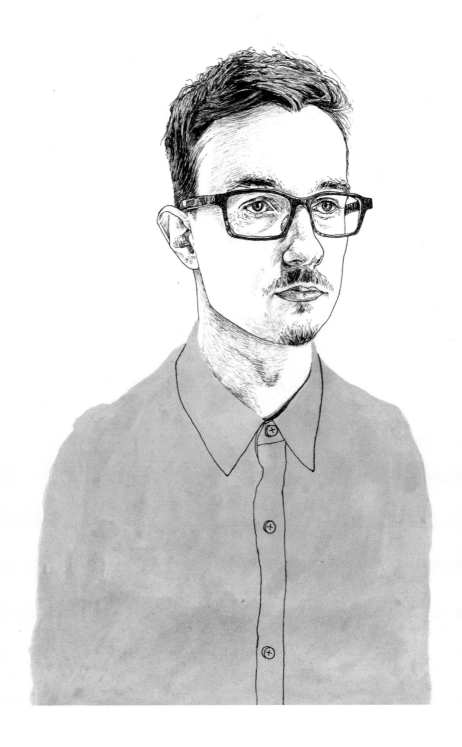

Self-portrait

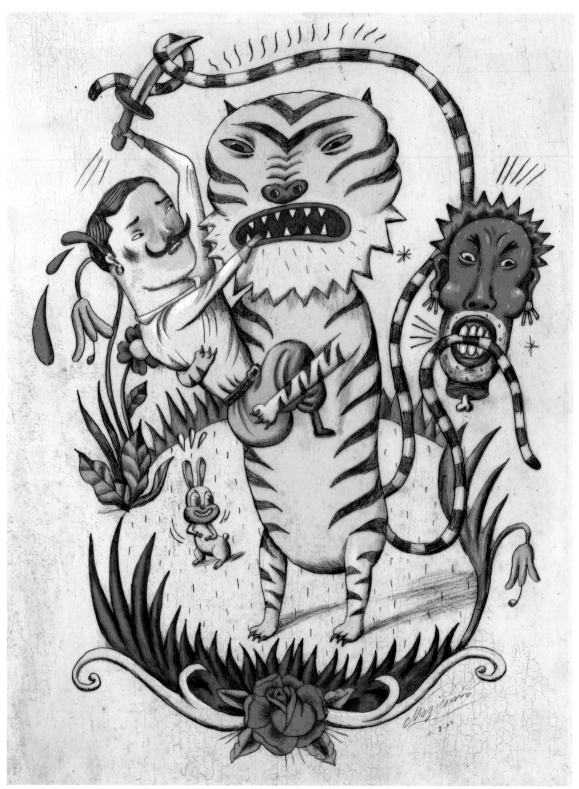

Pimtiger

MAGICOMORA

www.sergiomora.com

TEXT BY **CECÍLIA DÍAZ**

Sergio Mora, aka Mágicomora, is a daring kaleidoscope, incisive, psychotropic and colourist. He was born in 1975 in Barcelona, the city where he received his training (Escuela de Artes y Oficios – Schools of Arts and Trades – La Llotja), lives, paints, experiments, feels and creates. If we look at the world through his eyes, sharp as well as utopian, we discover a genial mythology that blends those icons with which each and every of us identify in some manner, with the fantastic and the spectacular, the surprising and the illusory.

As multidisciplinary as it gets, his prolific work takes us to subversive, circuslike worlds of beautiful monsters and monstrous fantasies through any of his disciplines: painting, illustration, video, comic and performance among others. His personal artistic catalogue and mostly his pictorial idiosyncrasy, have turned him into the greatest exponent of the Peninsula´s Pop Surrealism, moving him to exhibit his work at the international level, edit books, publish in numerous reviews and make commercial campaigns and other endless collaborations.

Mágicomora grips the spectator through an illusionist´s imaginary, making her live a visual experience that will perennially remain in the subconscious. A symbolic imaginary that is ingrained in him, since its work cannot be separated from him, as a secondary, chameleonic and camouflaged actor in that fiction; a cameo in its own painting.

Agent: helen@agencyrush.com
Licensing: admin@monday2friday.es

Sergio Mora aka Mágicomora es un caleidoscopio audaz, incisivo, psicotrópico y colorista, nacido en Barcelona en 1975, ciudad en la que se forma (Escuela de Artes y Oficios, La Llotja), reside, pinta, experimenta, toca y crea. Si miramos el mundo a través de sus ojos, tan perspicaces como utópicos, descubrimos una mitología genial que mezcla esos iconos con los que todos y cada unos de nosotros nos sentimos de alguna manera identificados, con lo fantástico y espectacular, lo sorpresivo e ilusorio.

Artista multidisciplinar donde los haya, su prolífica obra nos traslada a mundos subversivos, circenses, de bellos monstruos y monstruosas fantasías, en cualquiera de sus vertientes: pintura, ilustración, video, cómic y performance entre otras. Su personal decálogo artístico y sobre todo su idiosincrasia pictórica lo han convertido en el mayor exponente del Surrealismo Pop de la península, llevándole a exponer a nivel internacional, editar libros, publicar en numerosas revistas, realizar campañas de publicidad y un sinfín de colaboraciones más.

Mágicomora engancha al espectador a través de un imaginario de ilusionista, haciéndole vivir una experiencia visual que se quedará perenne en su subconsciente. Imaginario simbólico que lleva muy arraigado, ya que su obra no se puede separar de él mismo, como actor secundario camuflado y camaleónico, en esa ficción. Un cameo en su propio cuadro.

Agent: helen@agencyrush.com
Licensing: admin@monday2friday.es

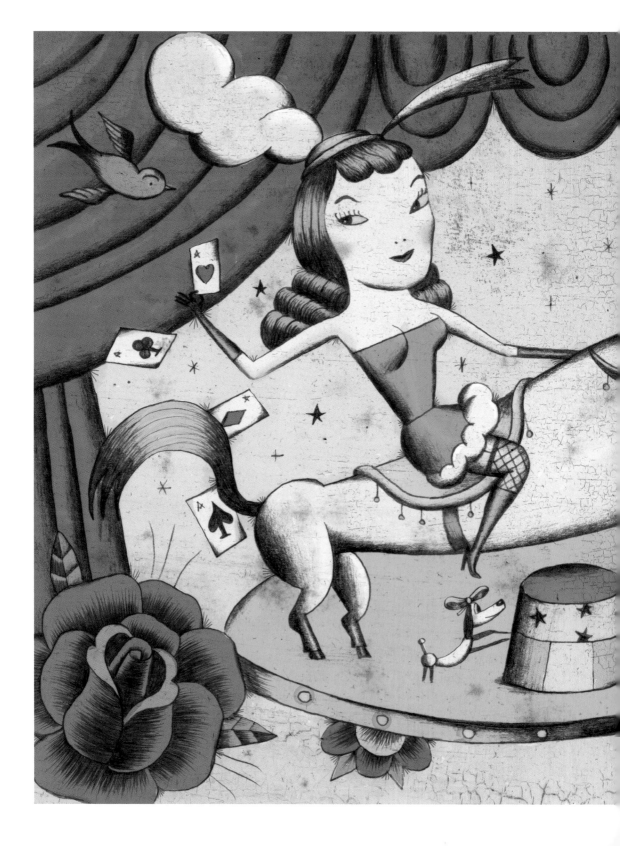

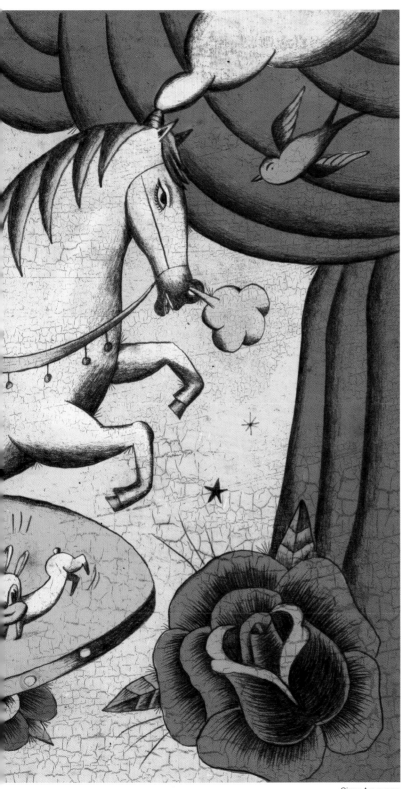

Circo Amazona

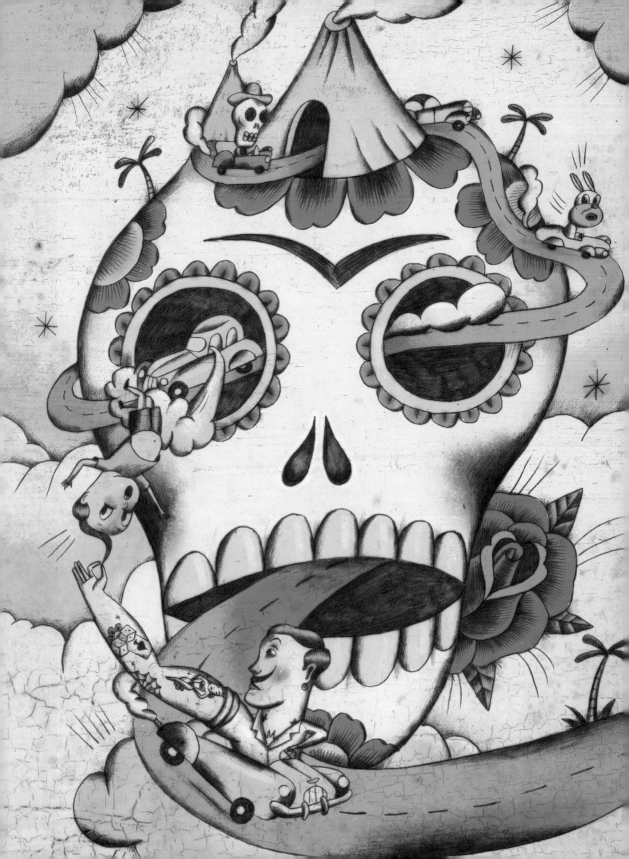

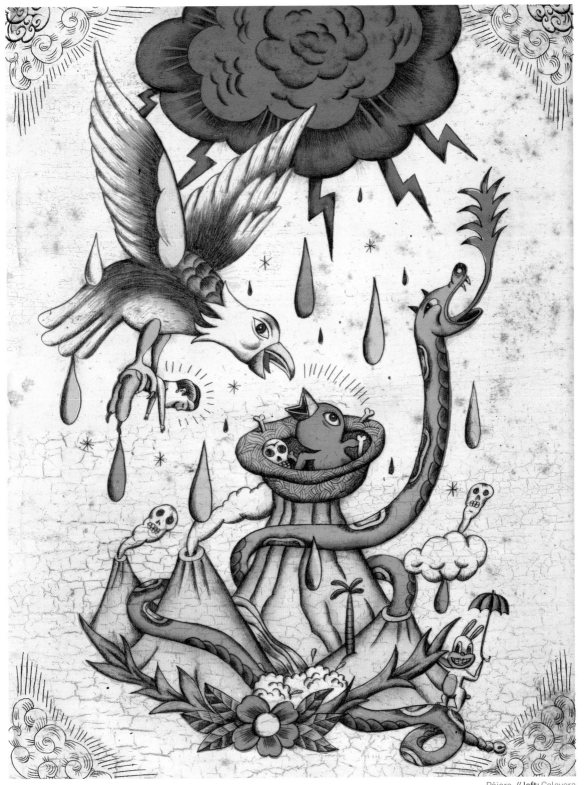

Pájaro // left: Calavera

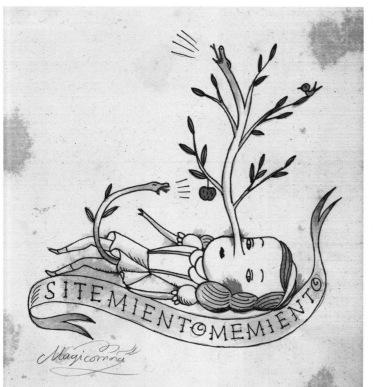

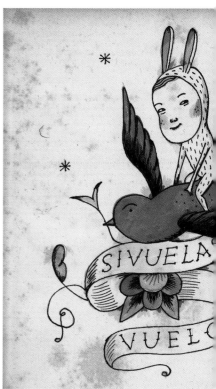

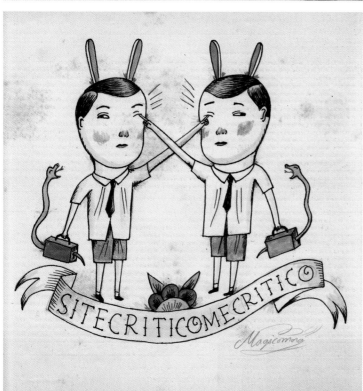

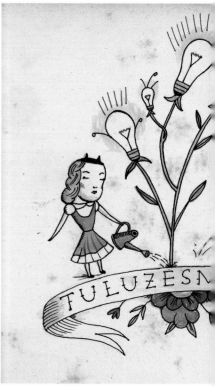

Top: Si te miento, me miento / Si vuelas, vuelo / Tu dolor es mi dolor

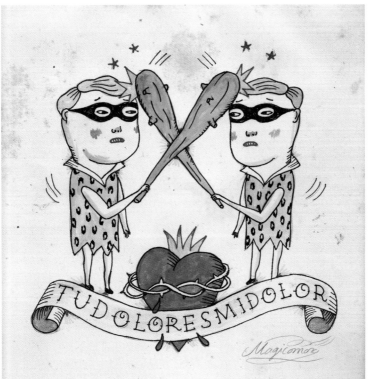

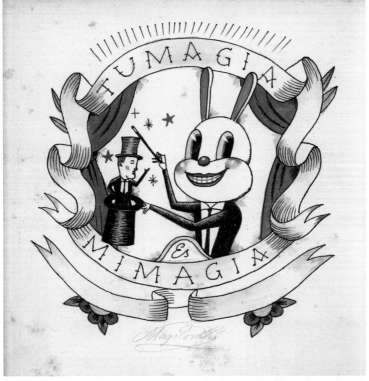

Bottom: Si te critico, me critico / Tu luz, es mi luz / Tu magia, es mi magia

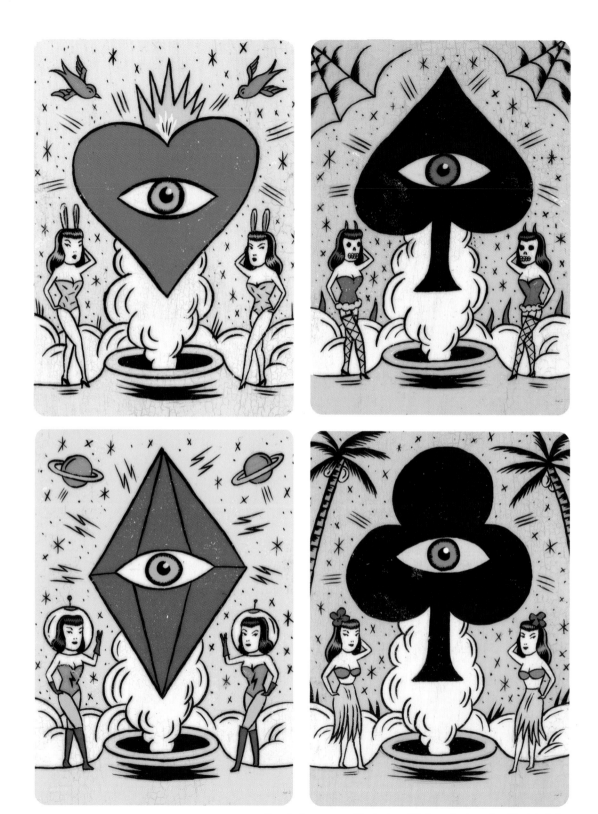

Top: As de corazones / As de picas // Bottom: As de rombos / As de treboles

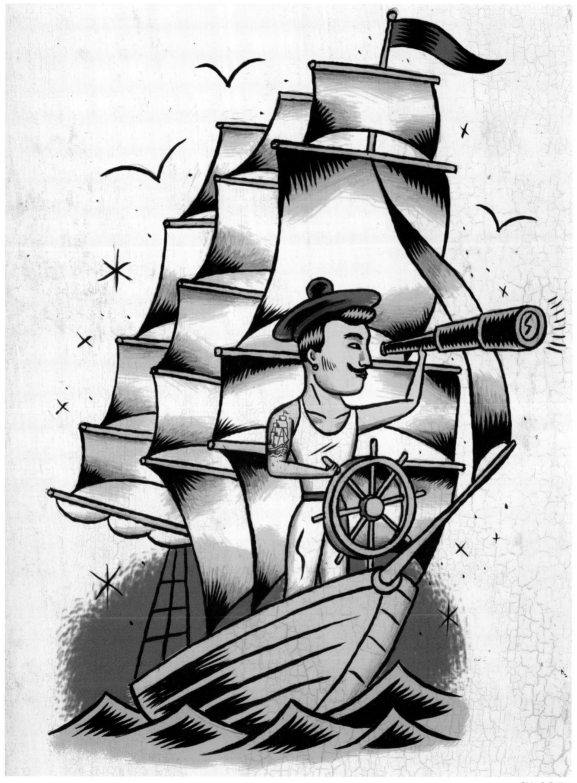

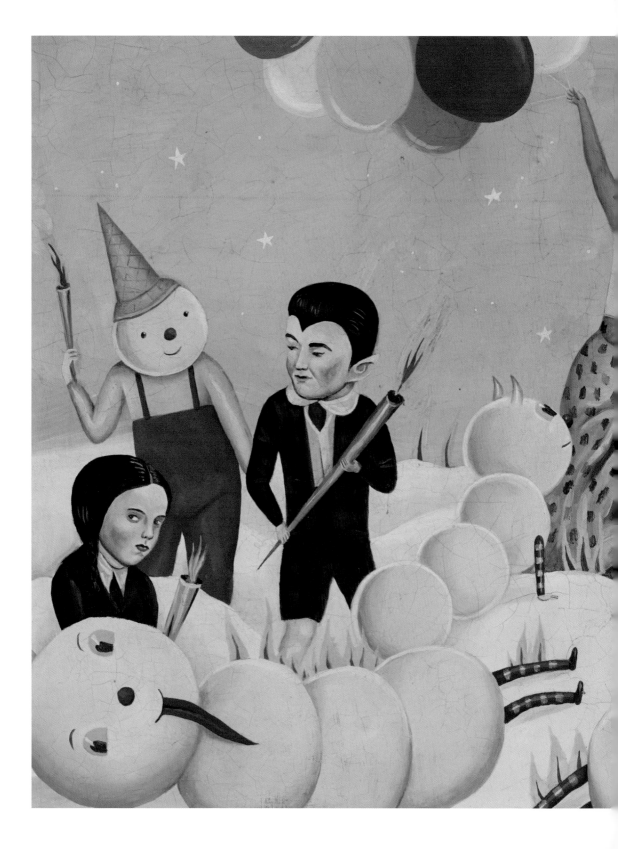

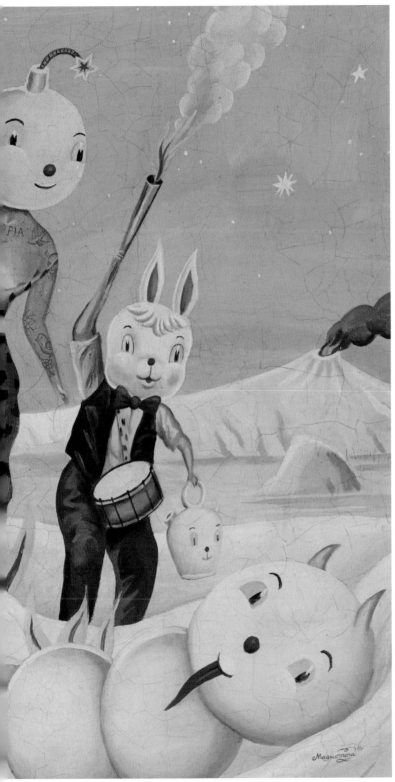

Children of the revolution

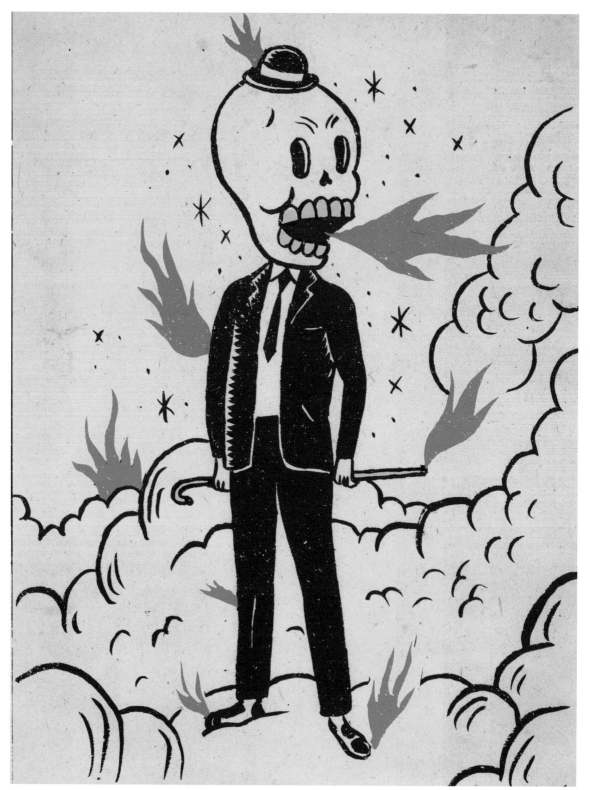

untitled

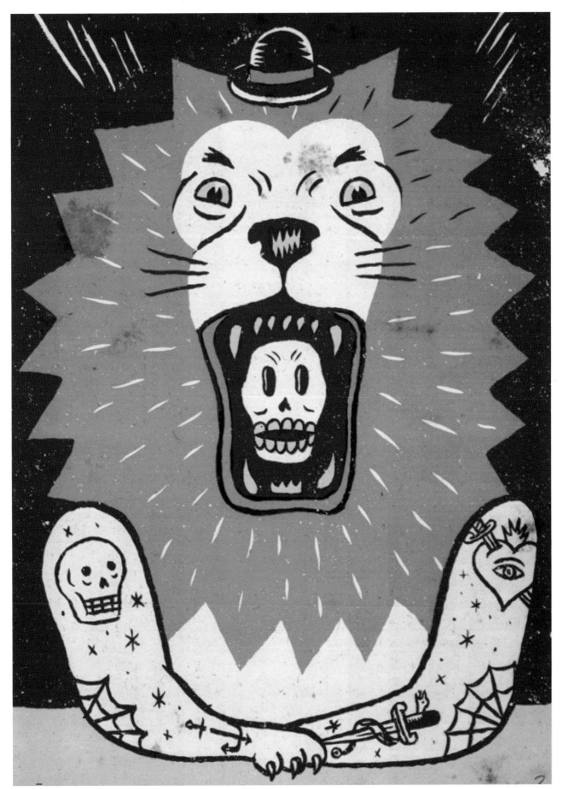

untitled

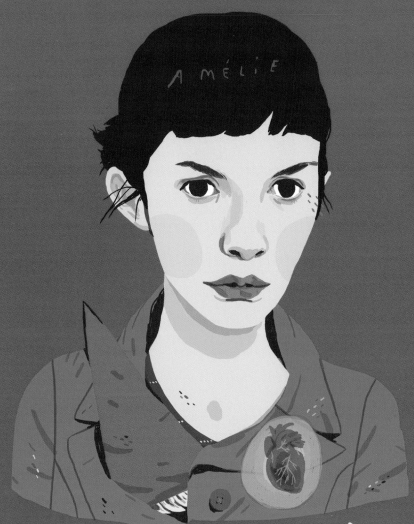

TIMES ARE HARD FOR DREAMERS

IVONNA BUENROSTRO

heartbeatsclub.tumblr.com

Ivonna Buenrostro is an illustrator originally from Mexico.

Her project Heartbeats Club is an attempt to belong together with the films, series, books and music she relates to, feels or admires.

With this personal project, she has managed to create a piece of art that had been sent to more than 15 countries.

Ivonna Buenrostro es una ilustradora de origen mexicano.

Su proyecto Heartbeats club es un intento de pertenecer a las películas, series, libros o música con los que se relaciona, siente o admira.

Mediante este proyecto personal, ha logrado crear arte que ha sido enviado a más de 15 países.

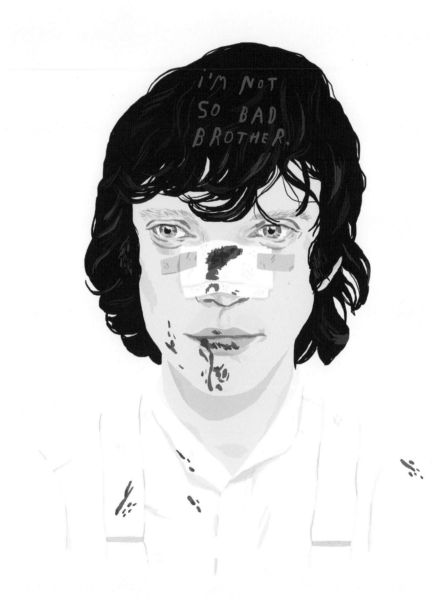

Clockwork Orange

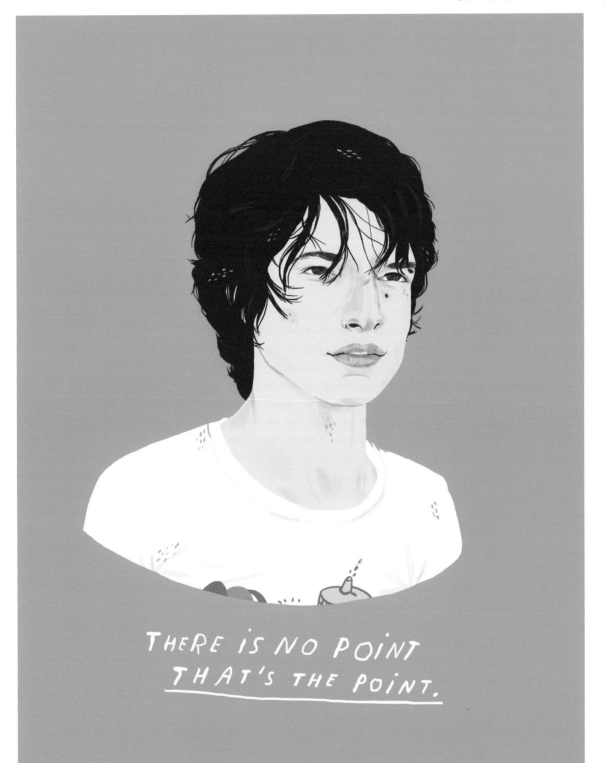

We need to talk about Kevin

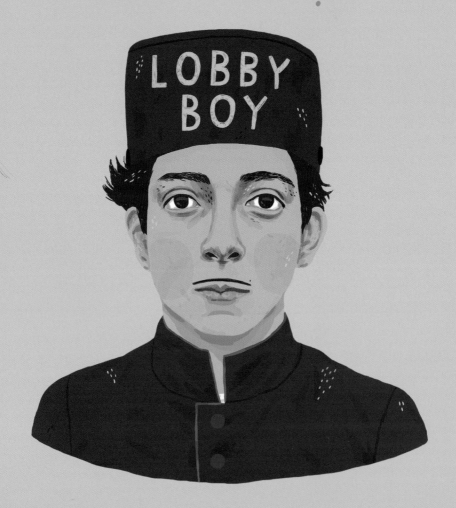

Lobby boy

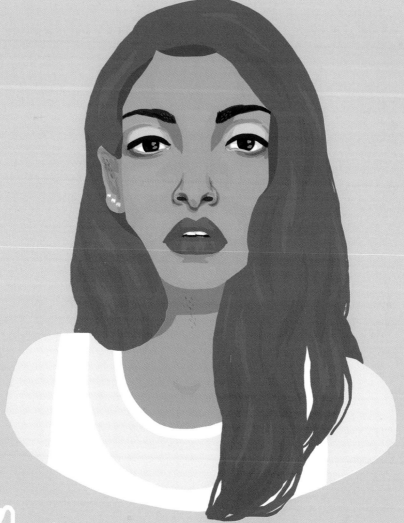

FEELINGS O
JUST LI

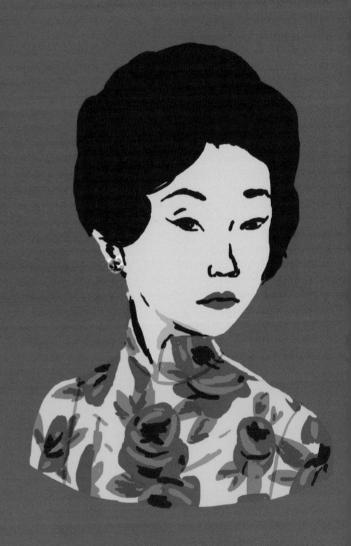

i THOUGHT i

CREEP UP
THAT.

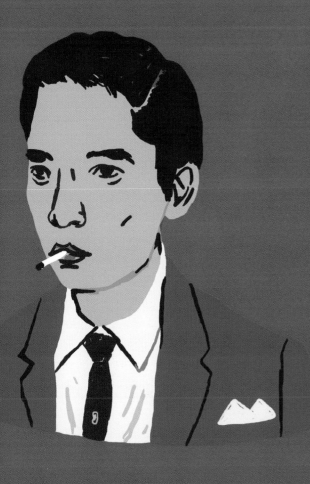

IN CONTROL.

In the mood for love

DON'T BE A

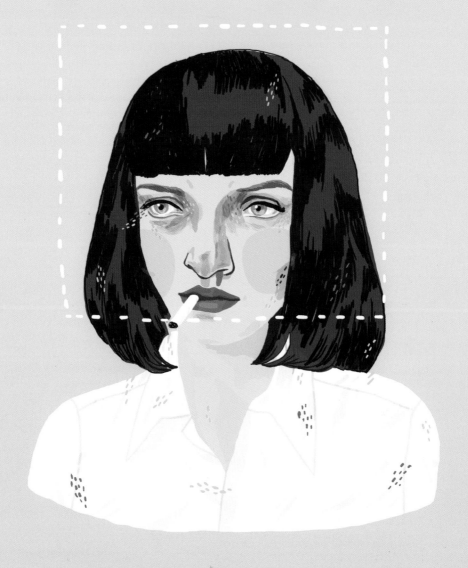

Pulp fiction

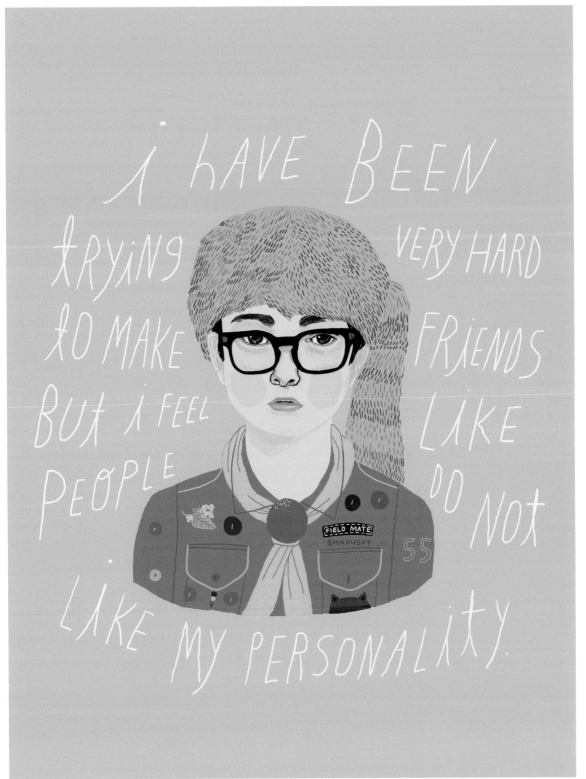

Sam Shakusky

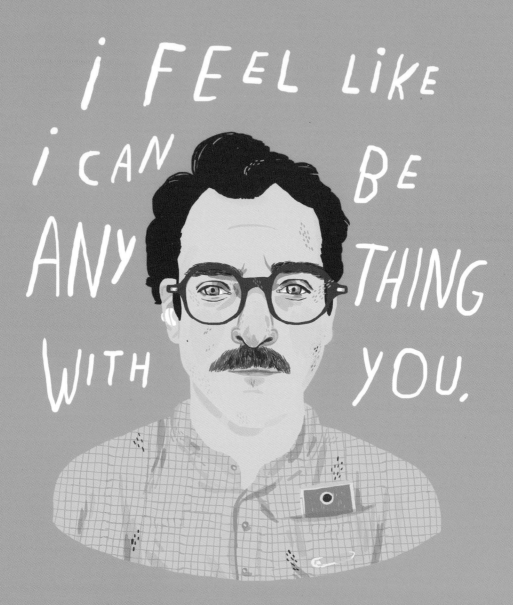

Her

WHERE DO YOU WANT TO GO?

—WHEREVER YOU MAY TAKE ME.

Chungking express

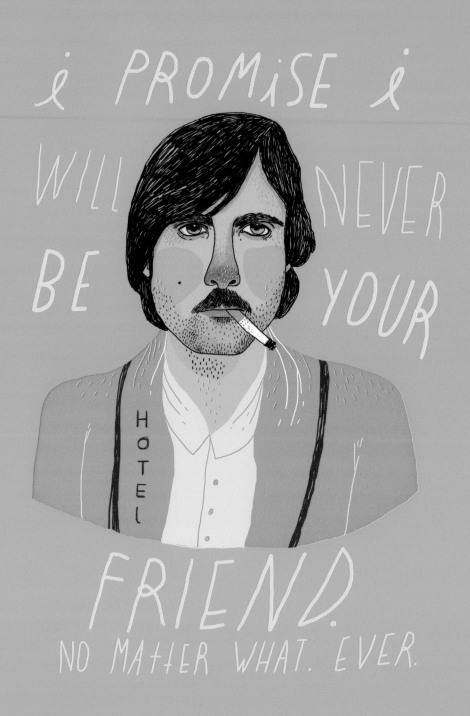

Hotel Chevalier

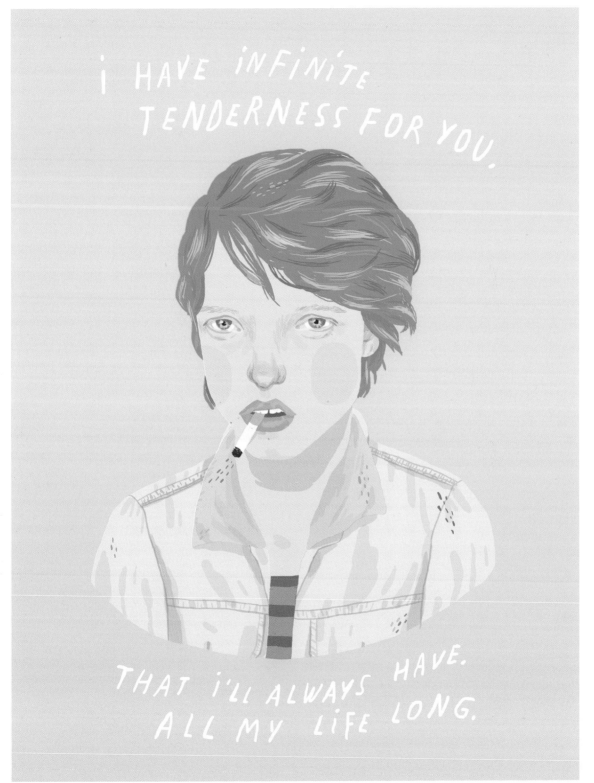

La vie d'Adèle

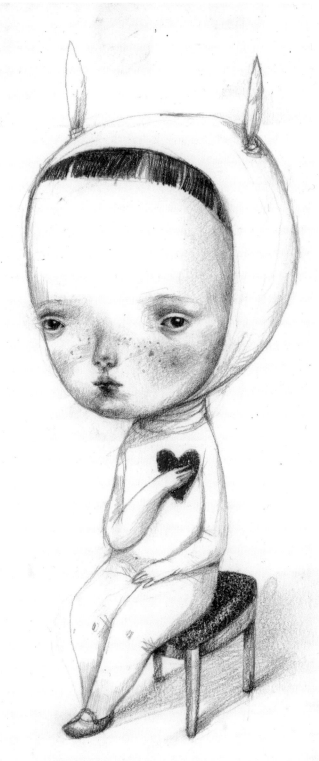

DILKA BEAR

dilkabear.tumblr.com

Dilka was born in Almaty, in present day Kazakhstan, when it was still the Soviet Union. Drawing has always been her passion; she used to draw very much when she was little, and this really didn't make her parents very happy because she used to draw on books and newspaper, even on the walls of their house, or on her mother's dresses!

When she finally grew up a little , she decided to study architecture, because she let herself be talked into studying something "serious". However, after two years she decided that it had been a bad decision and so she began to study art instead.

Dilka graduated not very long after that, and she found herself working as a graphic designer , and finding it very boring indeed, she moved to italy when she was 28, but there she couldn't find any kind of job at all. She was lucky though: a friend gave her a few old tubes of acrylic paint and some small pieces of wood that she had found in a street market, cut to a proper size. Dilka started to paint, just some paintings of animals at first, mainly bears, but they were kind of ugly. She hadn't quite come up with her own style yet, although her first works were kind of sweet. Then she tried to paint people: her characters always looked like children because there's something of her own in each of them, and she never wanted to grow up. She is still a child, deep down. Most of her works tells stories, she feels that she is a painter and a storyteller all at once.

Sometimes she can be inspired by people or by things that happen around her, with books that she read, or by stories that just materialize in her mind .

Dilka nació en Almaty, actualmente Kazajistán, cuando todavía existía la Unión Soviética. El dibujo siempre ha sido su pasión. De pequeña solía dibujar muchísimo, pero sus padres no estaban muy contentos porque lo hacía en libros, periódicos y hasta en las paredes de casa ¡o en los vestidos de su madre!.

Cuando por fin se hizo un poco más mayor, decidió estudiar arquitectura porque siempre le habían dicho que tenía que estudiar algo "serio". Sin embargo, al cabo de dos años, creyó que había sido una mala decisión y por eso empezó a estudiar arte.

Dilka se graduó un poco más tarde y empezó a trabajar como diseñadora gráfica. Como le parecía aburrido, se mudó a Italia con 28 años, aunque allí no encontró trabajo. Pero tuvo suerte: un amigo le dio unos tubos viejos de pintura acrílica y unos trozos de madera que encontró en un mercadillo y que tenían el tamaño adecuado. Dilka empezó a pintar primero animales, sobre todo osos, pero le quedaron un poco feos. Todavía no había descubierto su propio estilo, aunque sus primeras obras eran muy dulces. Entonces intentó pintar personas: sus personajes siempre parecen niños porque hay algo de ella en cada uno de ellos, ya que nunca ha querido crecer. En el fondo, todavía es una niña. La mayoría de sus obras cuentan historias. Ella se siente pintora y cuentacuentos a la vez.

A veces se inspira en la gente o con las cosas que pasan a su alrededor, con los libros que lee o las historias que se materializan en su mente.

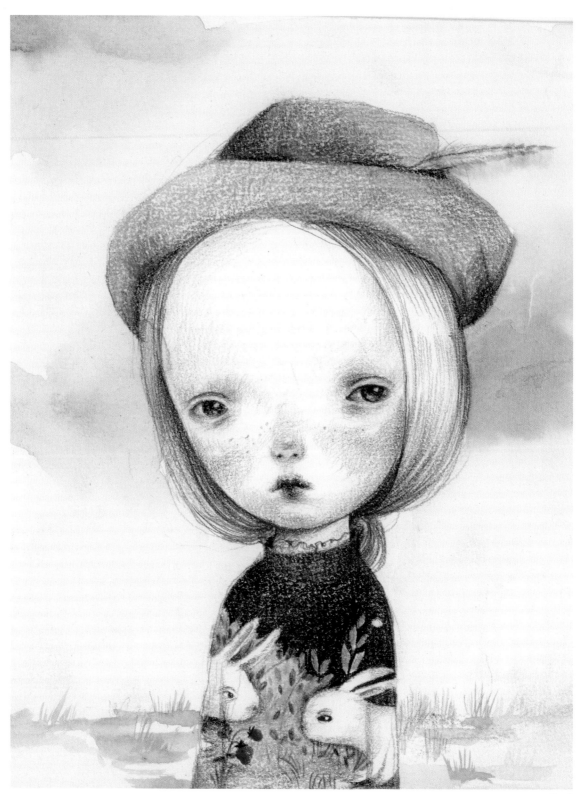

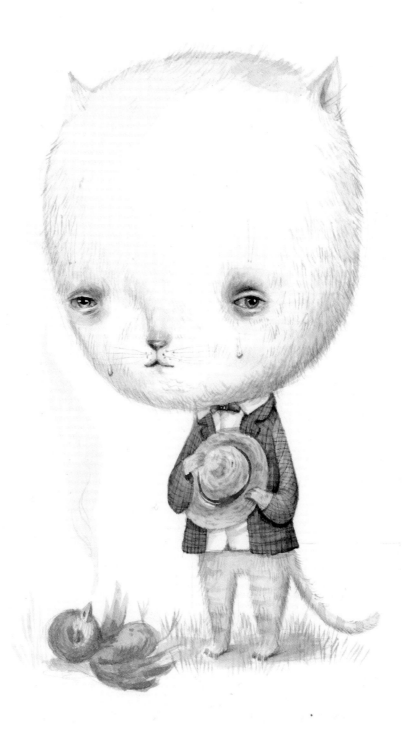

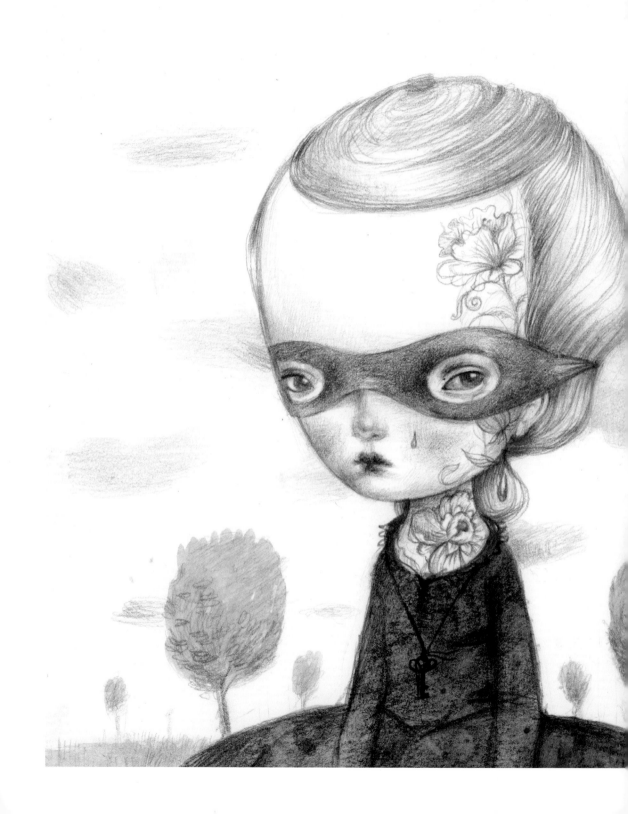

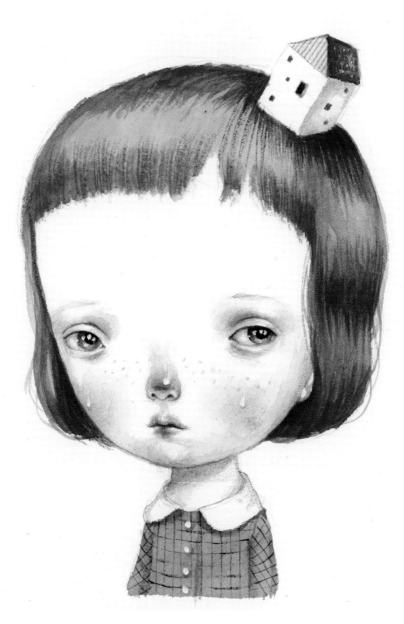

Day 13

Day 2

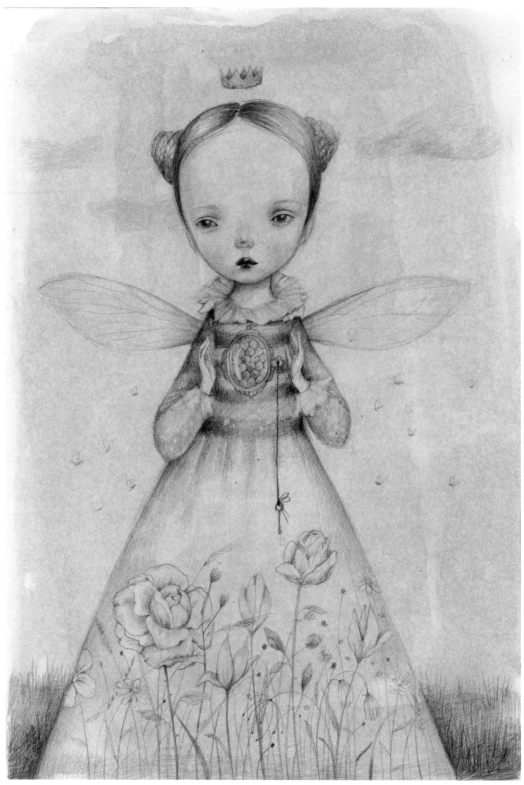

Bee queen

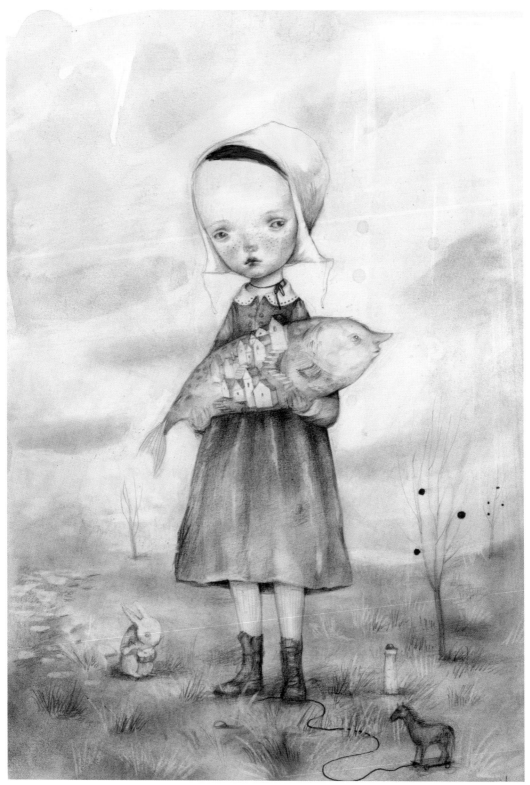

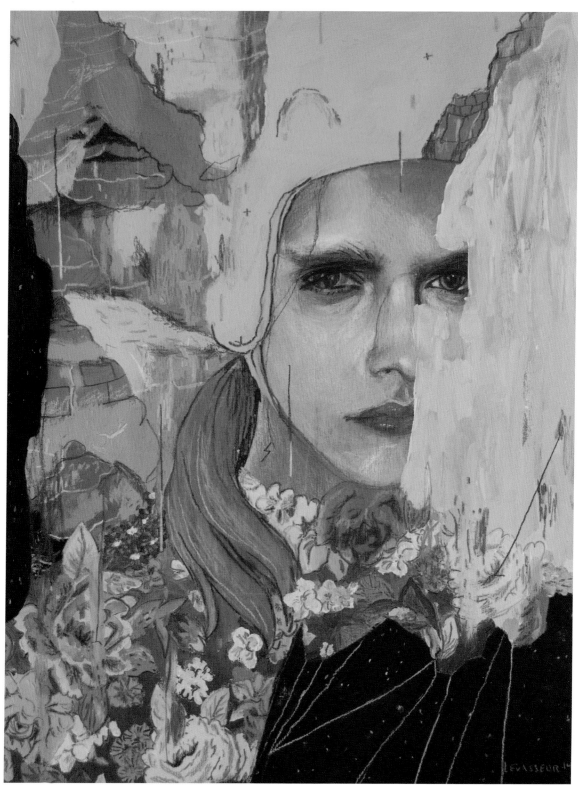

Le Rocher

ALEXANDRA LEVASSEUR

alexandralevasseur.com

Born in Mauricie in 1982, Alexandra Levasseur earned a Bachelor's degree in Fine Arts and Graphic Design at the University of Costa Rica in 2006. She then moved to Barcelona and completed post-graduate studies in Illustration and Techniques of Visual Communications at the EINA School of Art and Design in 2008. She spent the past few years focusing on her painting, the creation of animated films and her studies at the Mel Hoppenheim School of Cinema, Concordia University, in Montreal (ongoing).

Levasseur's work enjoys worldwide recognition. Invited to collaborate during the Fashion Week in Milan (2013) by Nick Night of SHOWstudio, London, she created drawings of the most renowned fashion shows. For many years now, numerous magazines have devoted articles and publications to her work: Juxtapoz, Decover, 24 images, Hi Fructose, Ignant, Supersonic Art, Boooooom, Exhibition-ism. Her film Table d'hôte was programmed in at several international festivals (Netherlands, Greece, Ukraine, Brazil, France).

Her works have been exhibited in prestigious museums and galleries: Mirus Gallery, San Francisco (2015 and 2013); Victoria and Albert Museum, London (2014-2015); Picasso Museum, Barcelona (2009); the Barra de Ferro space, Barcelona (2008). Alexandra Levasseur is represented on a permanent basis at Galerie ROCCIA in Montreal where she presents her third solo exhibition entitled Matière & Mémoire, in 2015.

Nacida en Maurice en 1982, Alexandra Levasseur se licenció en Bellas Artes y Diseño Gráfico por la Universidad de Costa Rica en 2006. Después se mudó a Barcelona y terminó sus estudios de posgrado en Ilustración y Técnicas de Comunicación Visual en la Escuela de Arte y Diseño EINA en 2008. Ha pasado los últimos años centrada en sus cuadros, en la creación de películas animadas y en sus estudios en la Escuela de Cine Mel Hoppenheim de la Universidad Concordia, en Montreal (en curso).

Las obras de Levasseur han logrado un reconocimiento mundial. Invitada para colaborar durante la Semana de la Moda de Milán (2013) por Nick Night de SHOWstudio, Londres, ha creado ilustraciones para los desfiles de moda más famosos. Desde hace muchos años, un gran número de revistas han dedicado artículos y publicaciones a sus trabajos: Juxtapoz, Décover, 24 images, Hi-Fructose, Ignant, Supersonic Art, Boooooom, Exhibition-ism. Su película Table d'hôte (El menú) fue emitida en varios festivales internacionales (Países Bajos, Grecia, Ucrania, Brasil, Francia).

Sus obras se han expuesto en museos y galerías de prestigio: la Galería Mirus, San Francisco (2013 y 2015); el Museo de Victoria y Alberto, Londres (2014-2015); el Museo Picasso, Barcelona (2009), y el espacio Barra de Ferro, Barcelona (2008). Alexandra Levasseur expone de forma permanente en la Galería Roccia de Montreal, donde ha presentado su tercera exposición en solitario titulada Matière & Mémoire (Materia y memoria) en 2015.

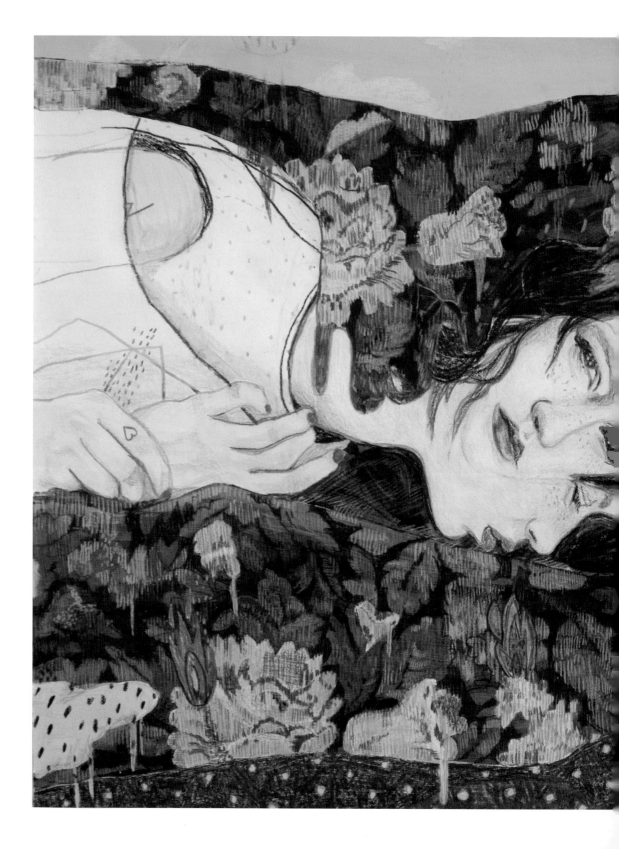

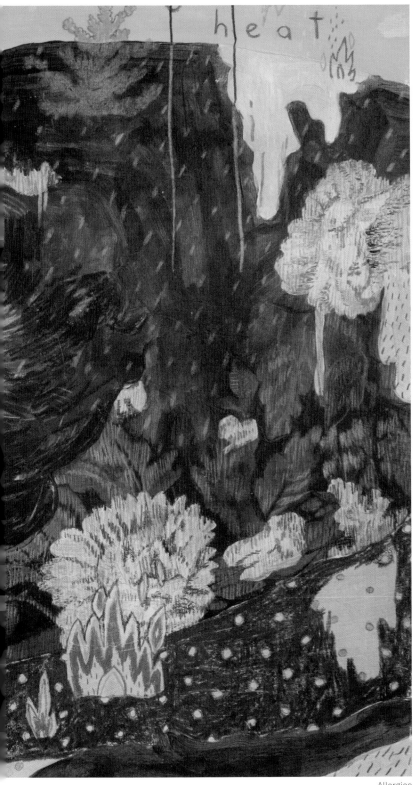

Allergies

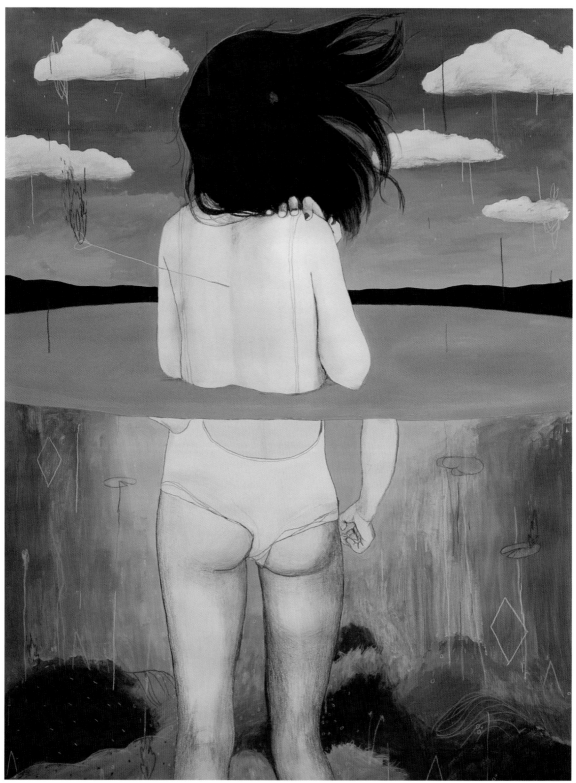

Terrain inconnu II

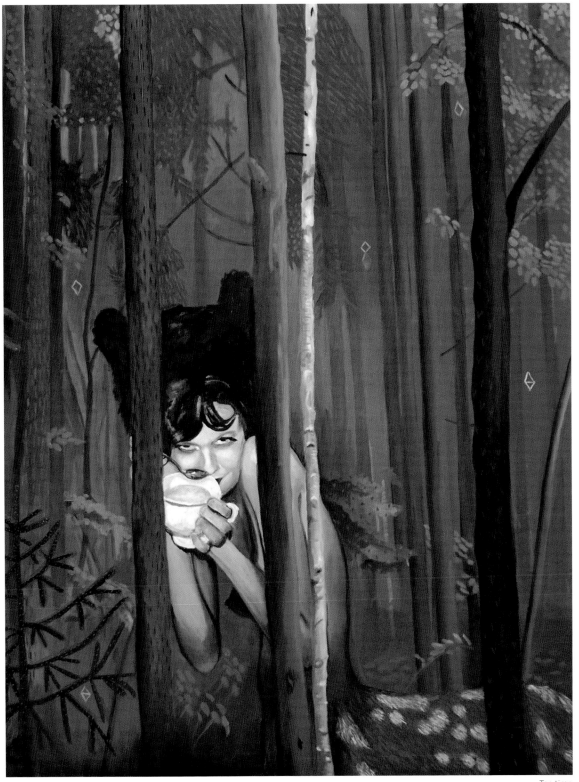

Tea time

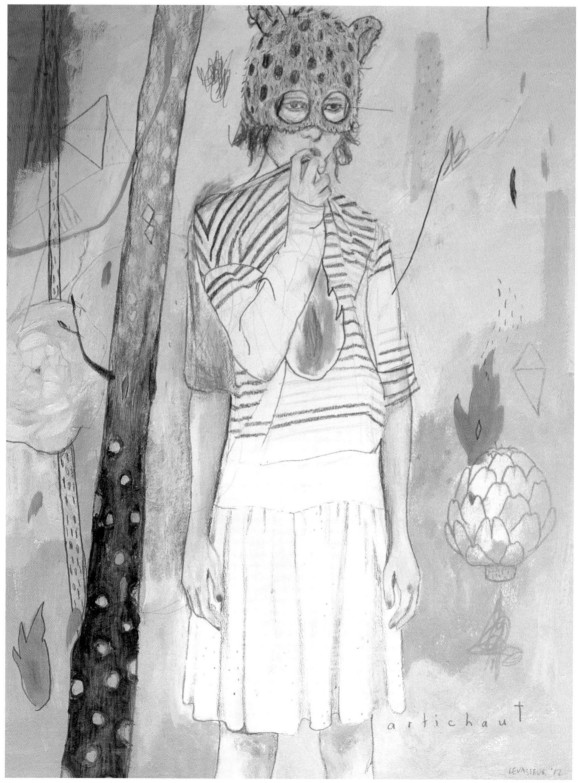

artichaut

LEVASSEUR '12

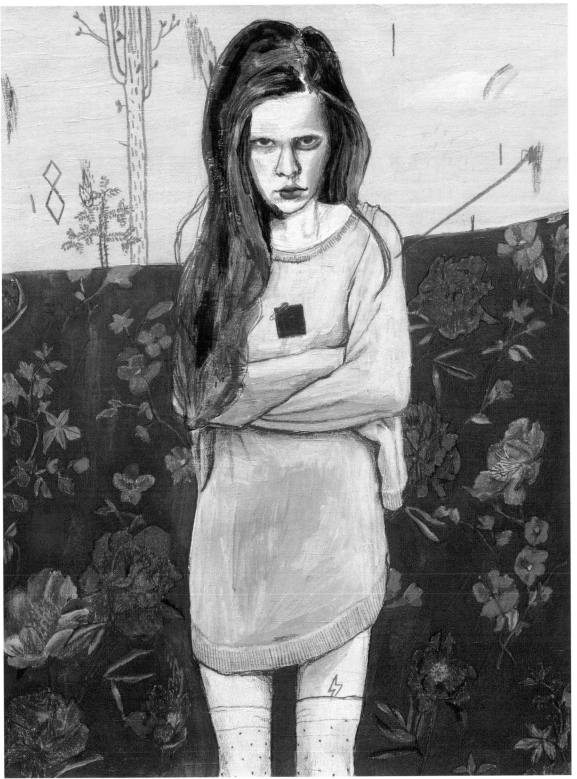

Carré Rouge

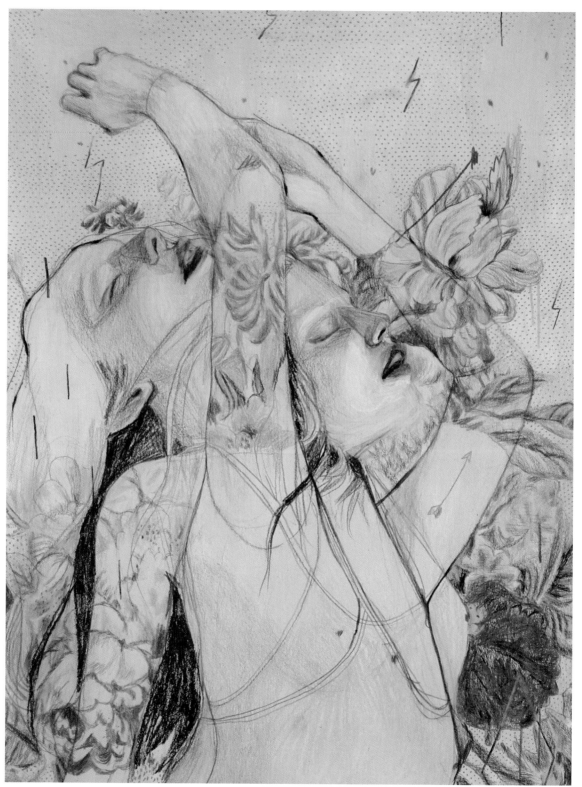

Dancer III

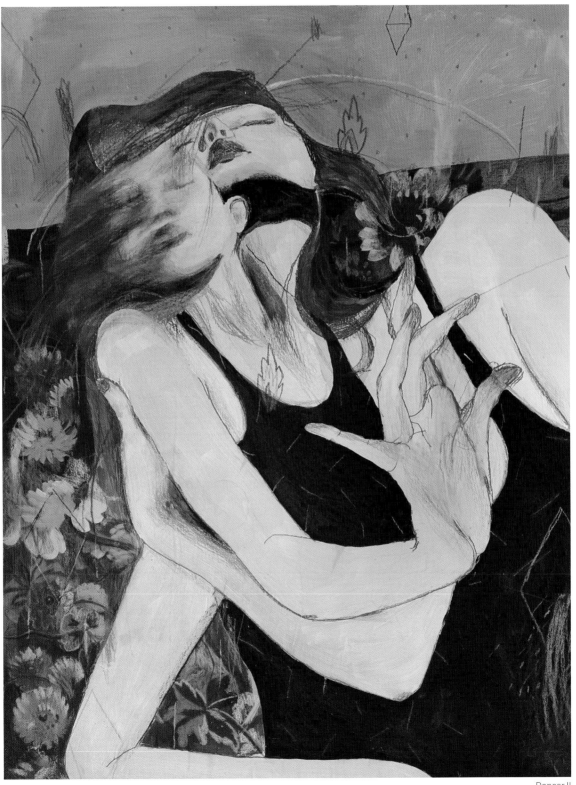

Dancer II

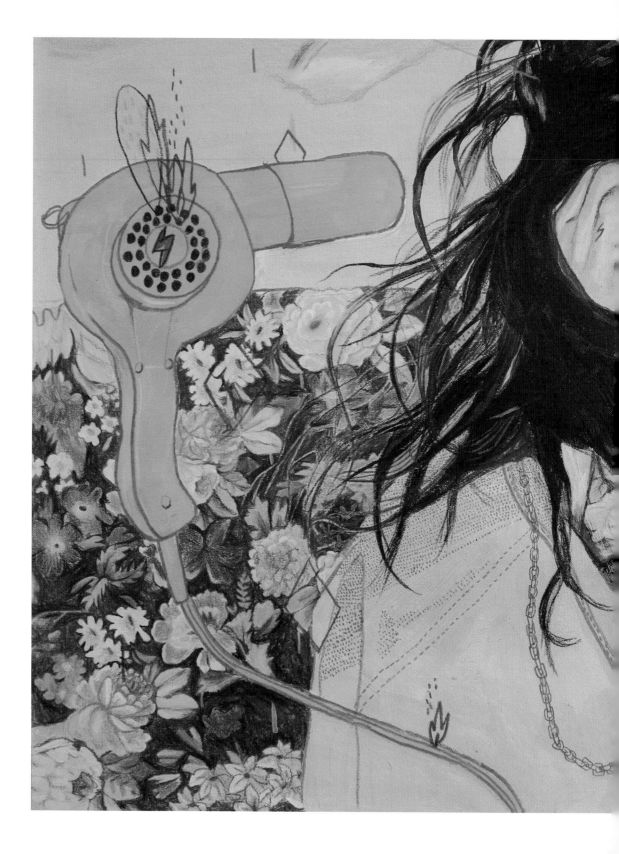

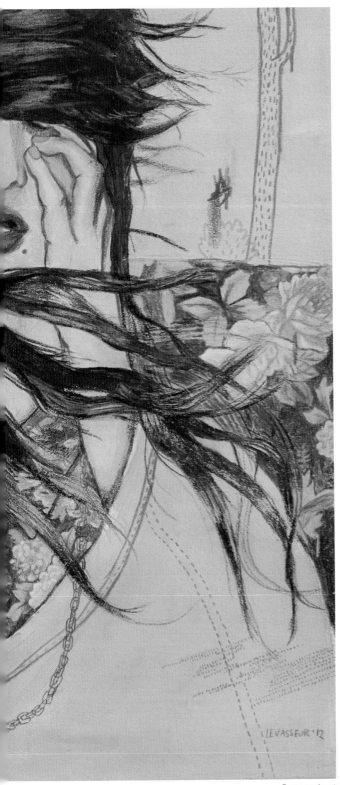

Summer heat

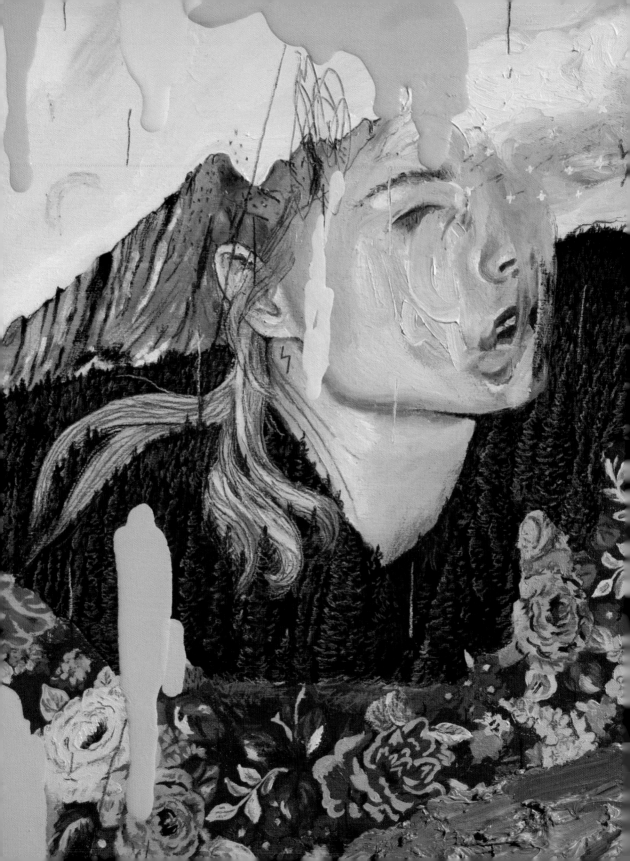

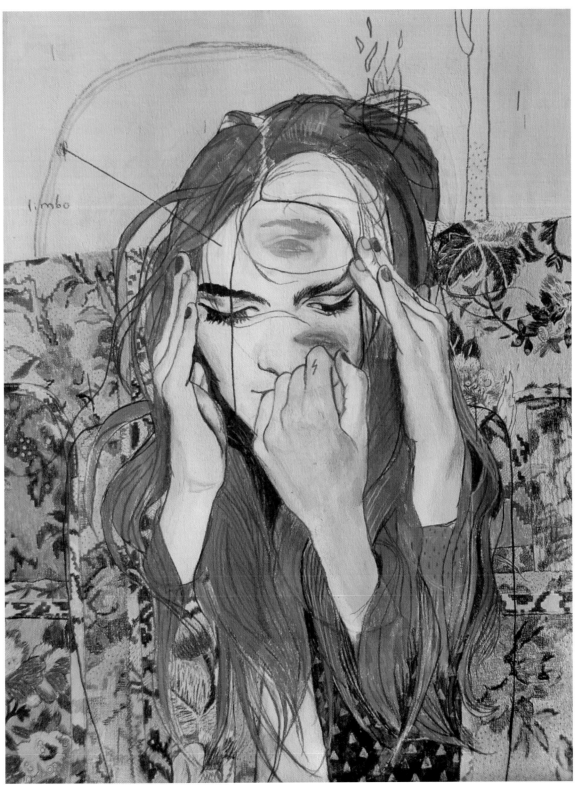

Limbo III // **left:** The river

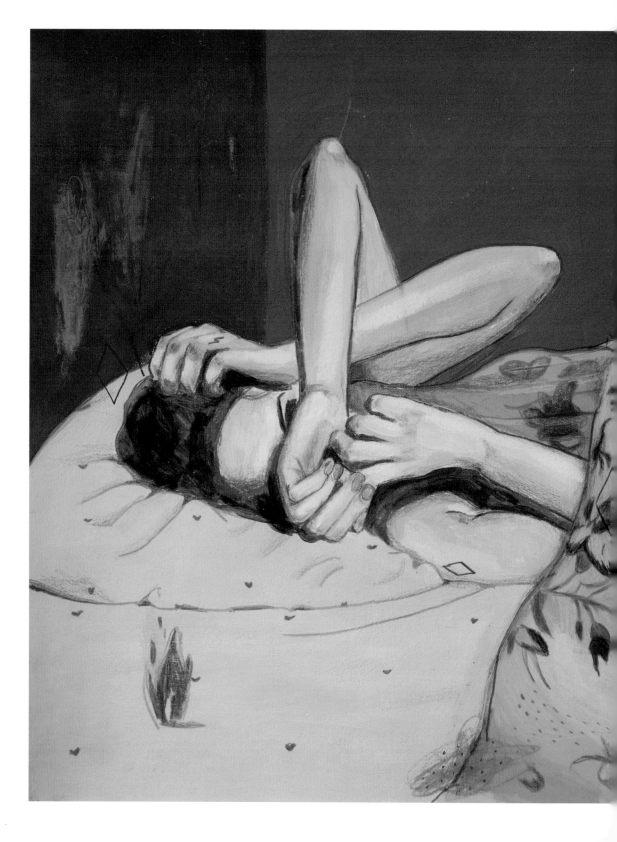

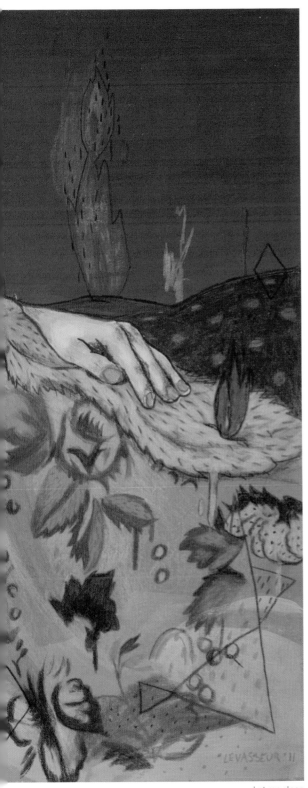

Let me sleep

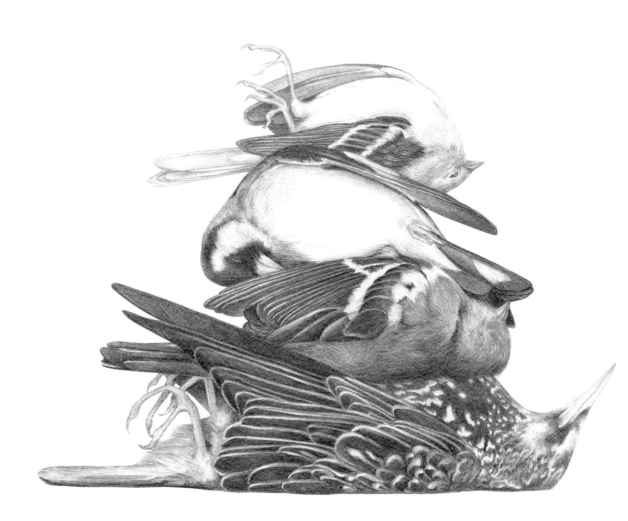

Flock

DENISE NESTOR

www.denisenestorillustration.com

Denise Nestor is an illustrator and artist based in Dublin. She graduated from Dun Laoghaire Institute of Art, Design and Technology in 2004. Her work has been published in 'The New York Times' and 'New York Magazine' as well as other international publications.

Denise Nestor es un ilustrador y artista afincado en Dublín. Se graduó en el Instituto de Arte, Diseño y Tecnología Dun Laoghaire en 2004. Sus obras han aparecido en The New York Times y en la Revista New York Magazine, así como en otras publicaciones internacionales.

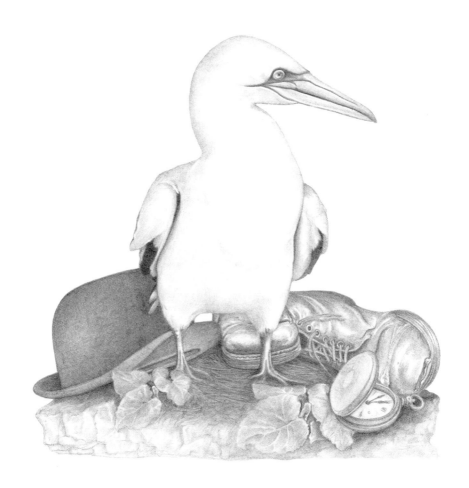

Gannet

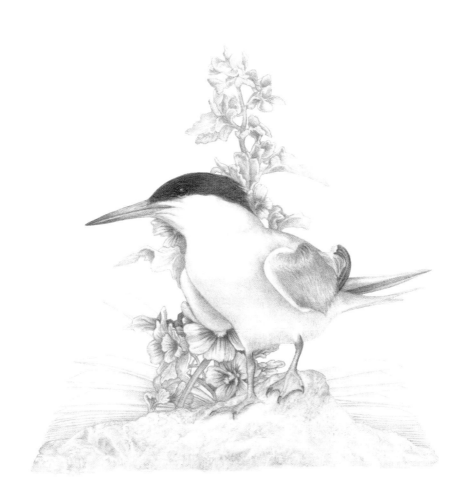

Tern

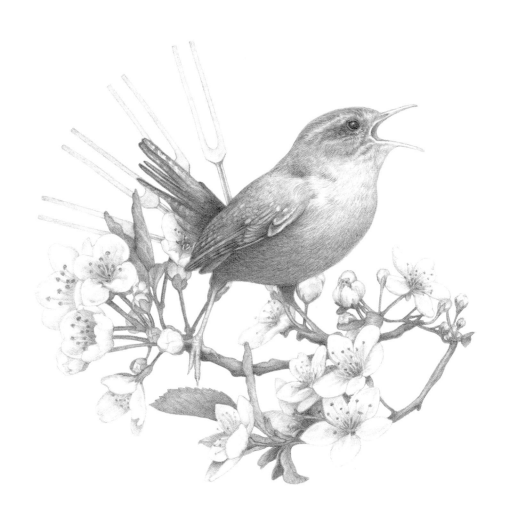

Wren

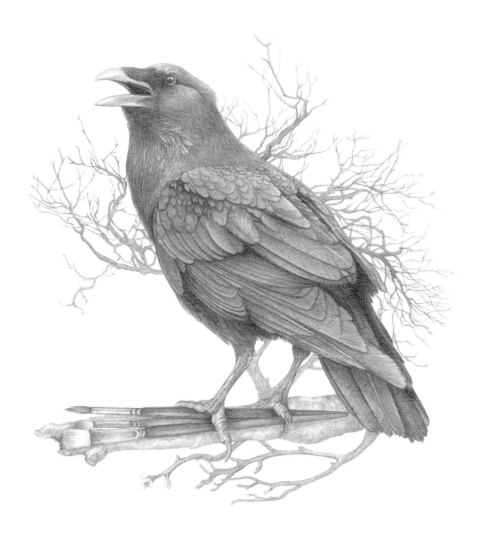

Raven

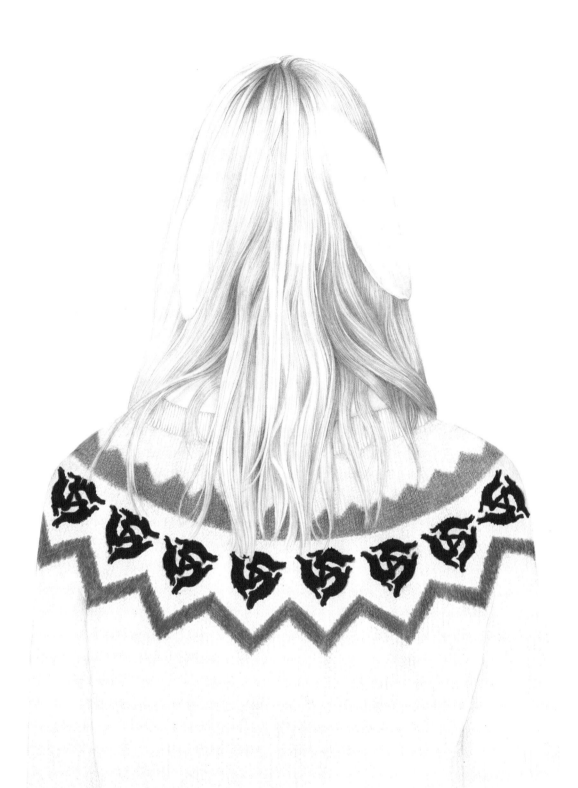

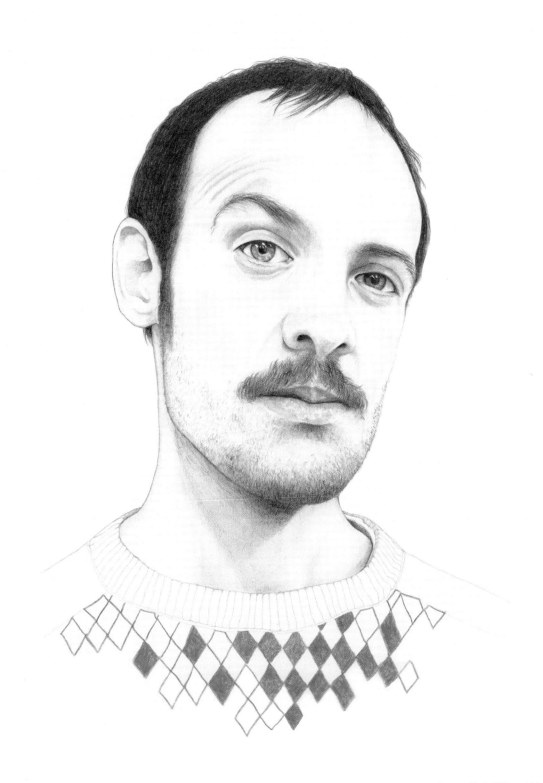

James // **left:** White rabbit

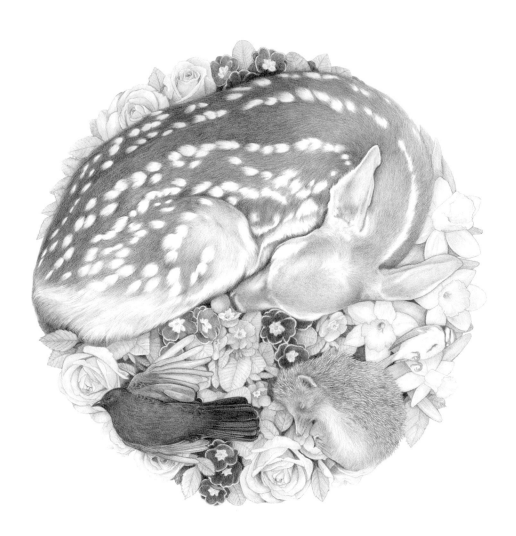

Wreath (February)

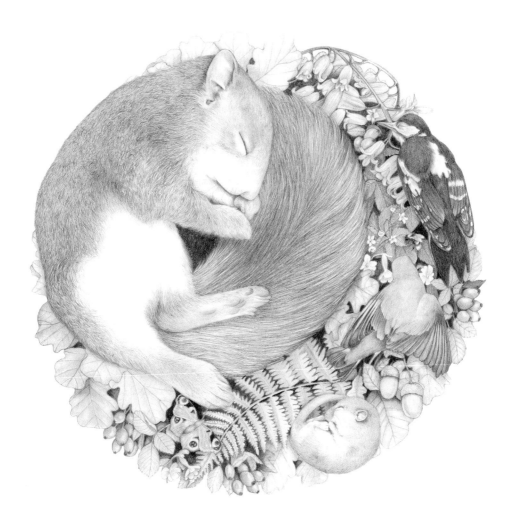

Wreath (Memento)

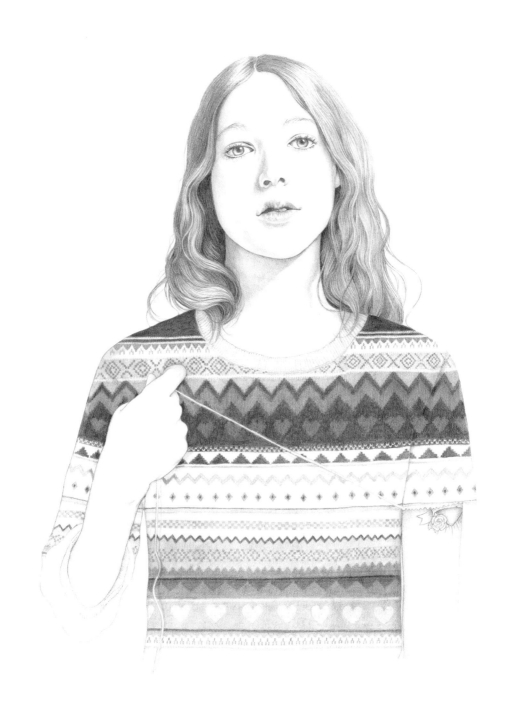

Unravel

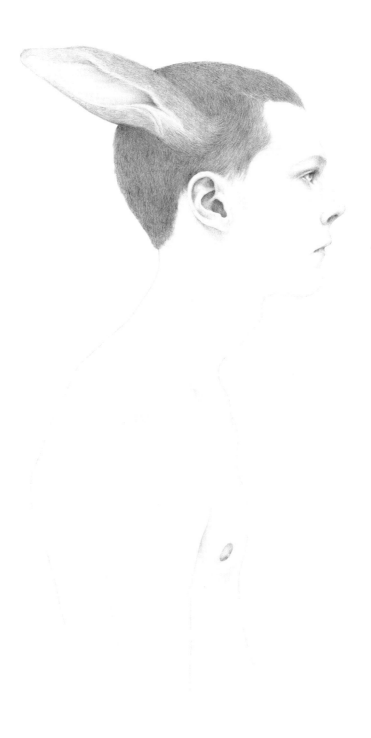

Untitled

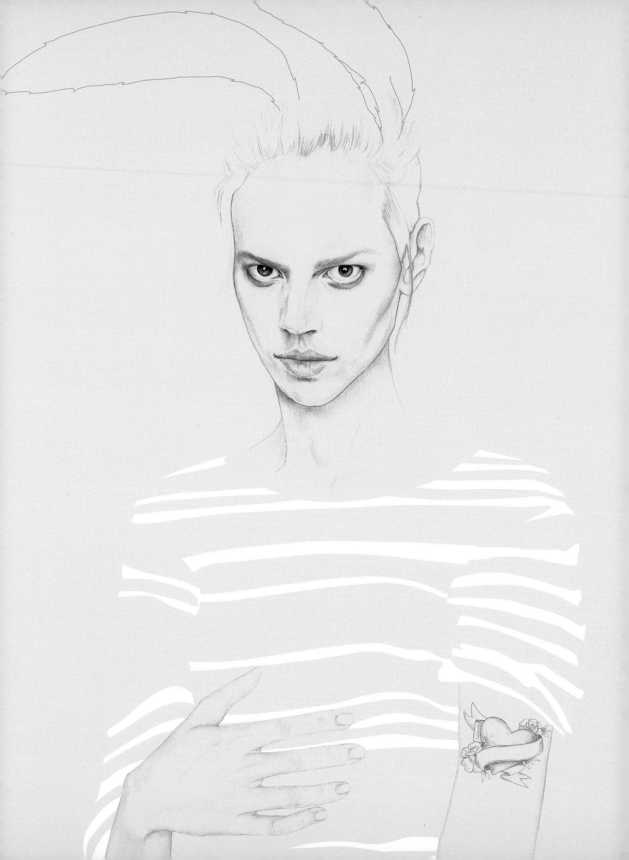

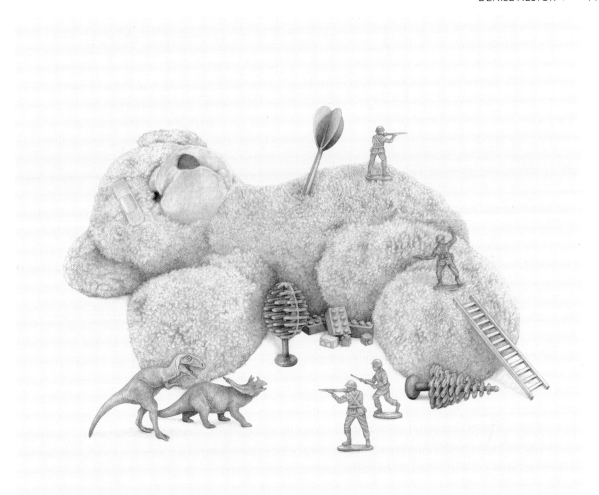

Tough Love // **left:** All the ways to say I love you

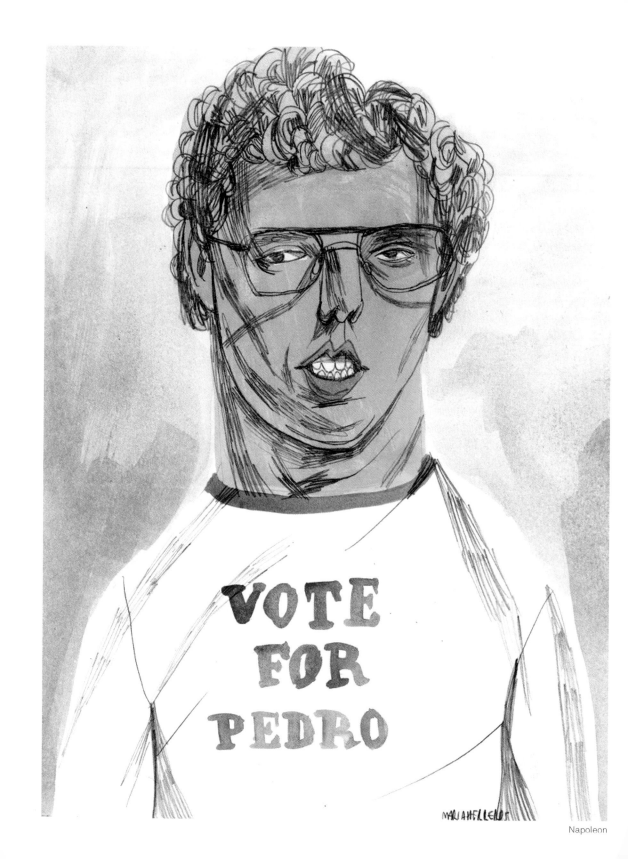

Napoleon

MARIA HERREROS

www.mariaherreros.es
www.mariaherreros.tictail.com

Maria Herreros is a freelance illustrator and comic book author based in Barcelona, Spain.

She divides her work between commissioned illustration for brands and mags; editorial work with several published comics and graphic novels, and her personal artistic work that she has exhibited in Barcelona, Porto, Berlin and Chile.

Independently she publishes his own zines and is part of several cultural projects.

Her style has a strange beauty that captivates the soul on its own personal way.

María Herreros es una ilustradora autónoma y autora de cómics, vive en Barcelona, España.

Su trabajo se divide en encargos de ilustraciones para marcas y revistas, trabajos editoriales con varios cómics y novelas gráficas publicadas, y diferentes obras artísticas que ha expuesto en Barcelona, Oporto, Berlín y Chile.

De manera independiente, publica su propia revista y forma parte de diversos proyectos culturales.

Su estilo cuenta con una extraña belleza que cautiva el alma con un estilo muy personal.

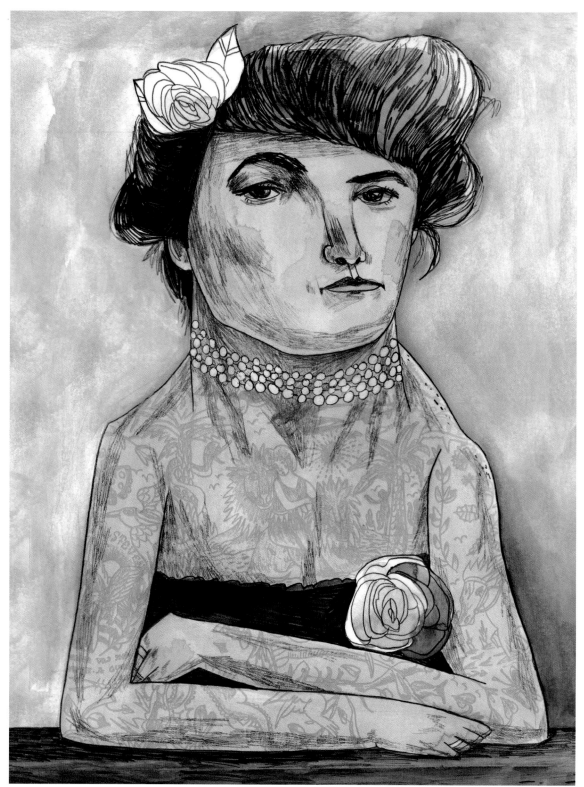

Fenomena

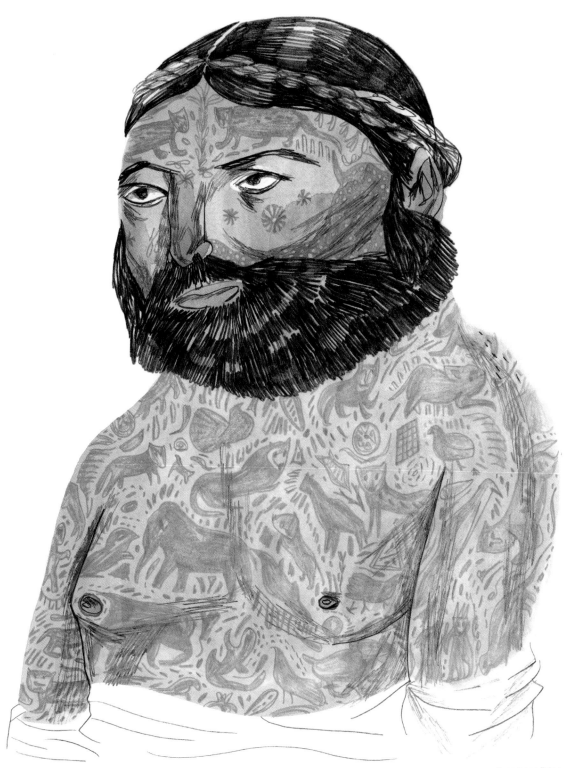

Fenomeno Prince

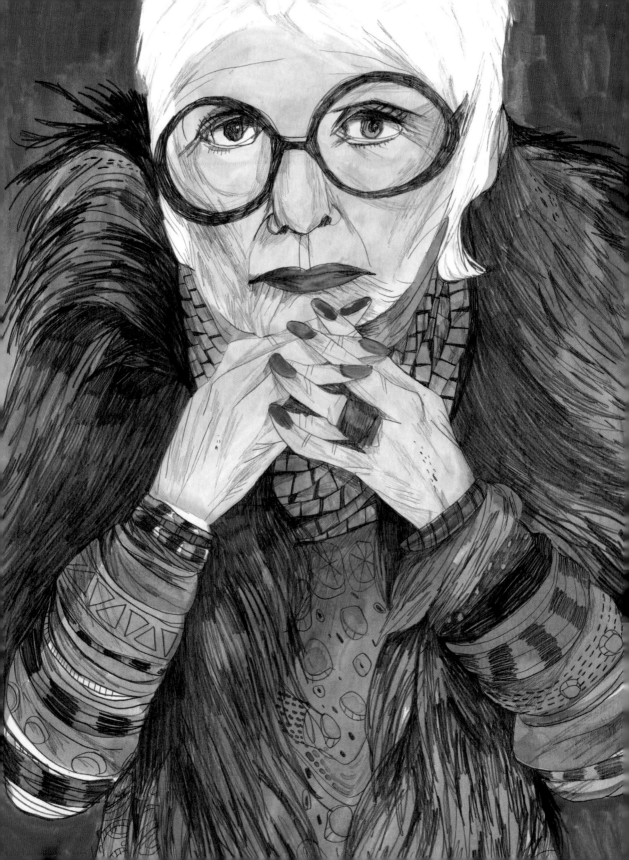

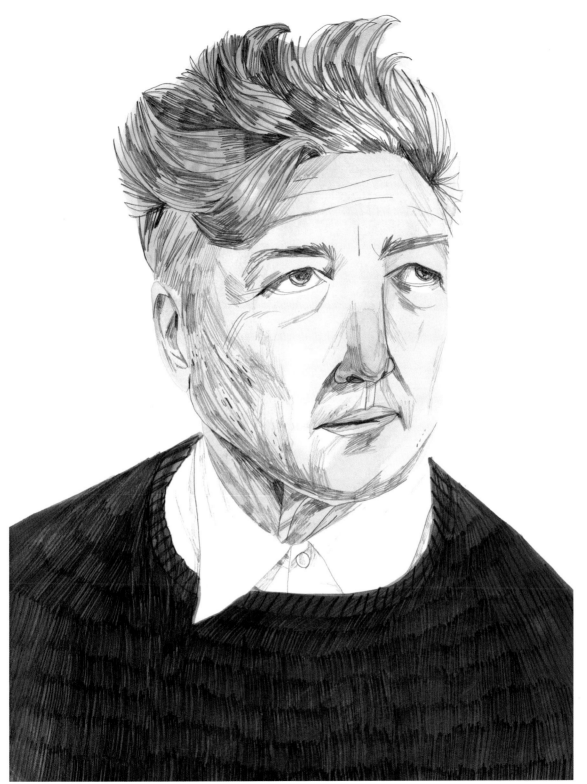

Lynch // **left:** Iris // **next page:** For Ema

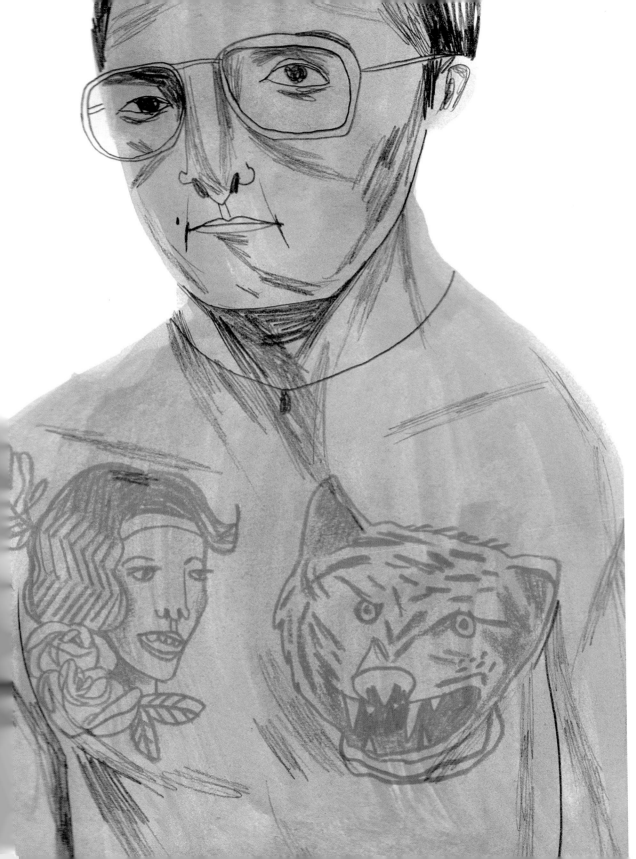

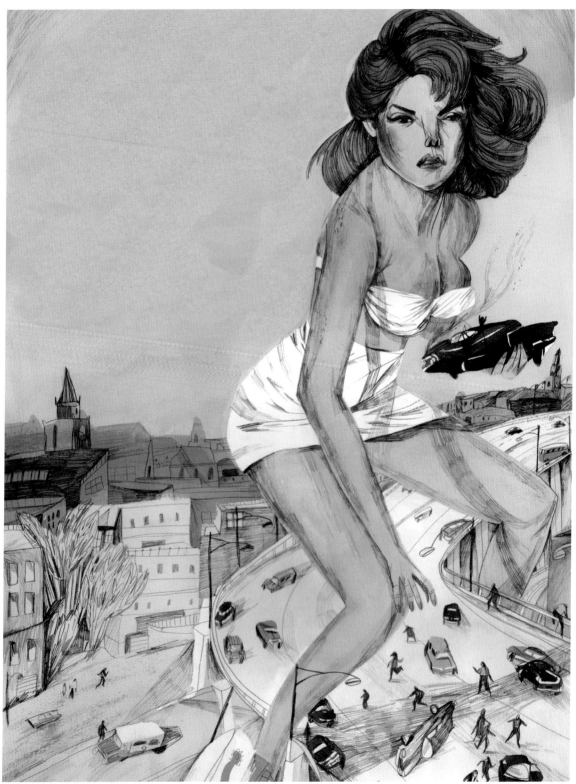

Mujer 50 pies

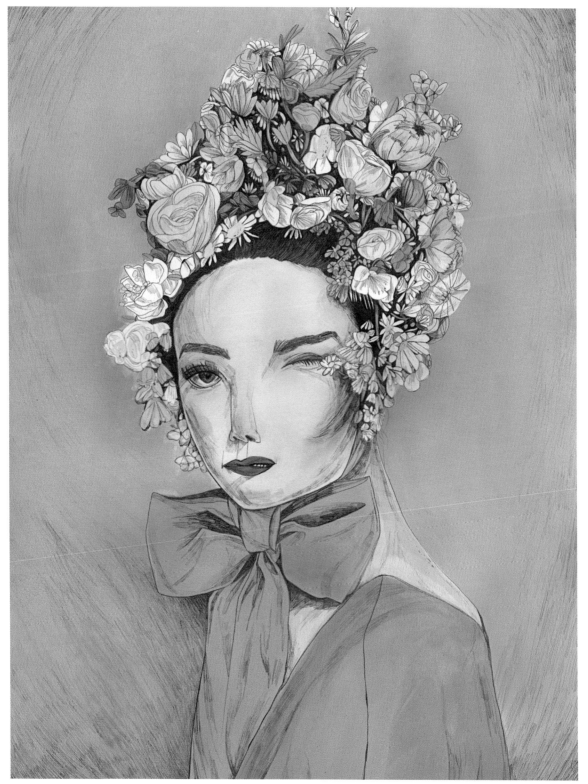

Botanical

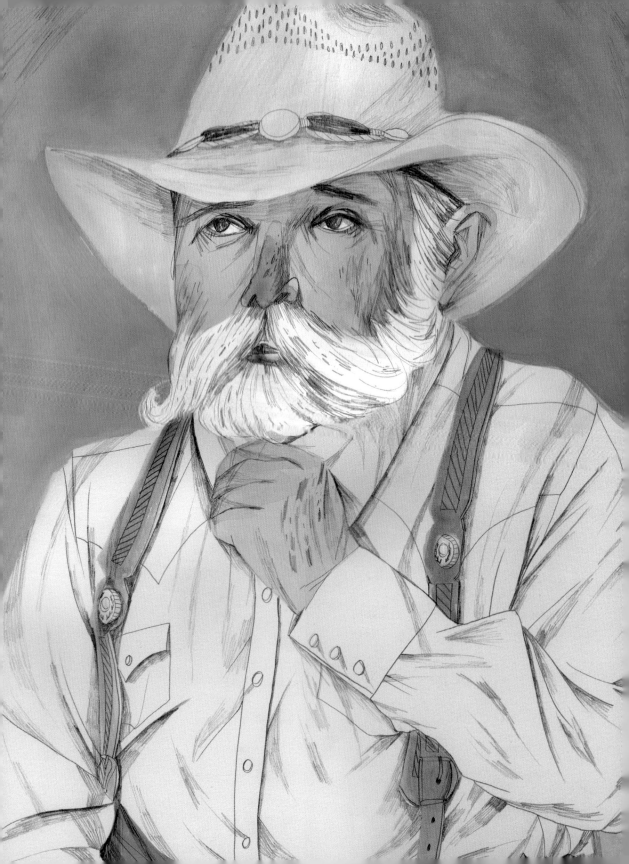

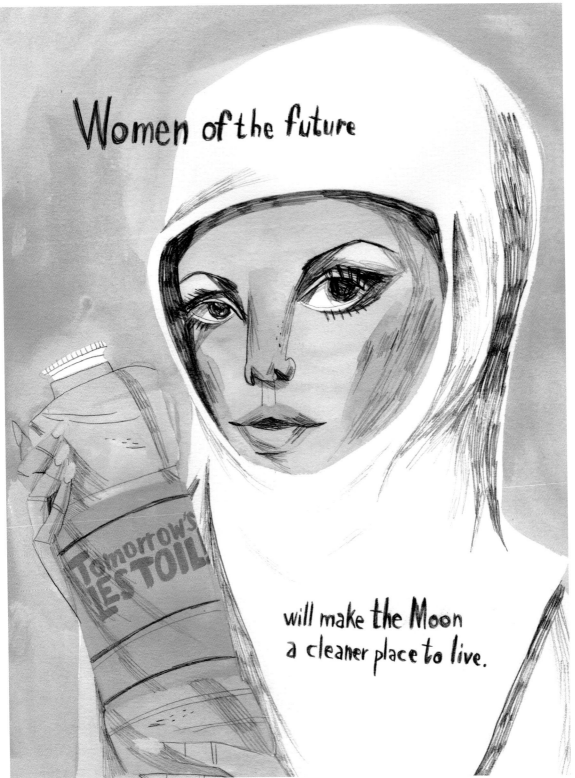

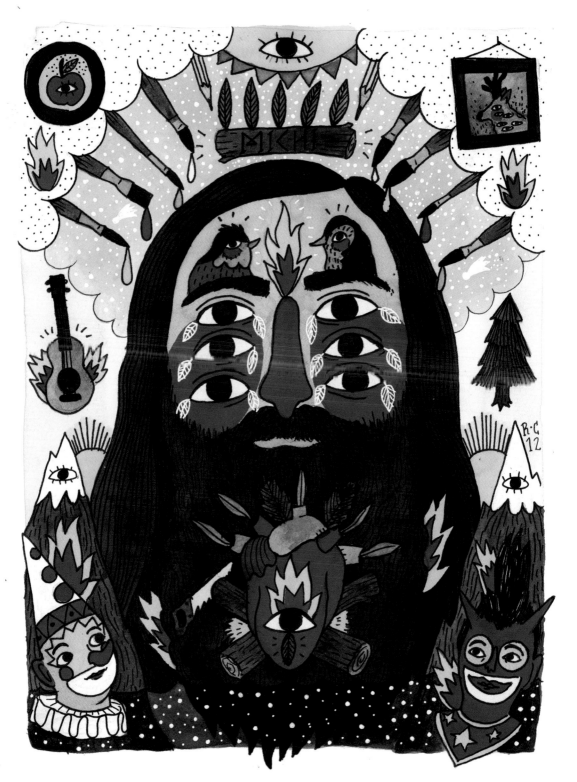

Michi

RICARDO CAVOLO

www.ricardocavolo.com

Ricardo Cavolo (Salamanca, 1982) is one of the most international Spanish illustrators. He has exhibited in galleries such as Mad is Mad and Espacio Valverde in Madrid, Atomica Gallery (London), Station16 (Montreal) and Ó! Galeria (Porto).

He has also worked on several advertising campaigns and for brands such as Nike, Converse, Coca Cola, Levi's… and on record covers and sleeves for music labels . As an illustrator he has published several books and a graphic novel with publishing houses such as SM, Periférica, Lunwerg, Límina (Italy) and Madriguera (Peru).

Ricardo has participated with his murals in festivals like Mural (Canada), Glastonbury Festival (UK), Cut Out Fest (Mexico) or MULAFEST (Spain), as well as working with Futbol Club Barcelona and has created murals for Urban Outfitters, Cirque du Soleil and YUL Project (Montreal).

His work is based on not standard characters living different lives. Using a strong color palette with a sort of naïf way of drawing, contrasting with themes and concepts for adults.

Ricardo Cavolo (Salamanca, 1982) es uno de los ilustradores españoles más internacionales. Ha expuesto en galerías como Mad is Mad y Espacio Valverde en Madrid; en la Atomica Gallery en Londres; en Station16 en Montreal, y en la galería Ó! en Oporto.

También ha trabajado en diversas campañas publicitarias y para marcas como Nike, Converse, Coca-Cola, Levi's, etc., ha hecho portadas de discos y textos de carátulas para discográficas. Como ilustrador, ha publicado varios libros y novelas gráficas para editoriales como SM, Periférica, Lunwerg, Límina (Italia) y Madriguera (Perú).

Ricardo ha participado con sus pinturas murales en festivales como Mural (Canadá), el Festival de Glastonbury (Reino Unido), Cut Out Fest (Méjico) o el Mulafest (España). También ha trabajado para el Fútbol Club Barcelona y ha diseñado murales para Urban Outfitters, el Cirque du Soleil y el Proyecto YUL (Montreal).

Sus obras se basan en personajes no estándares que viven vidas diferentes. Combina una paleta de colores vivos con una manera de dibujar bastante naïf y crea un contraste con temas y conceptos para adultos.

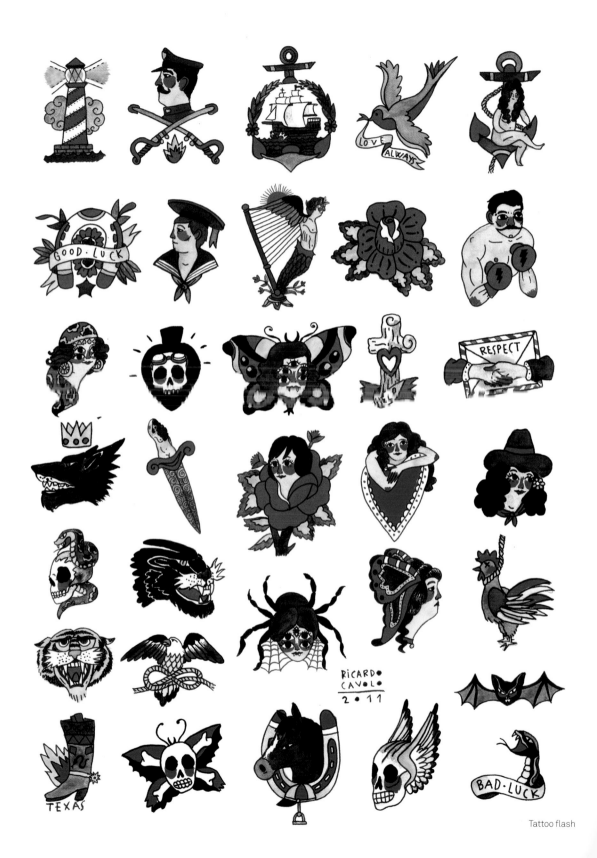

Tattoo flash

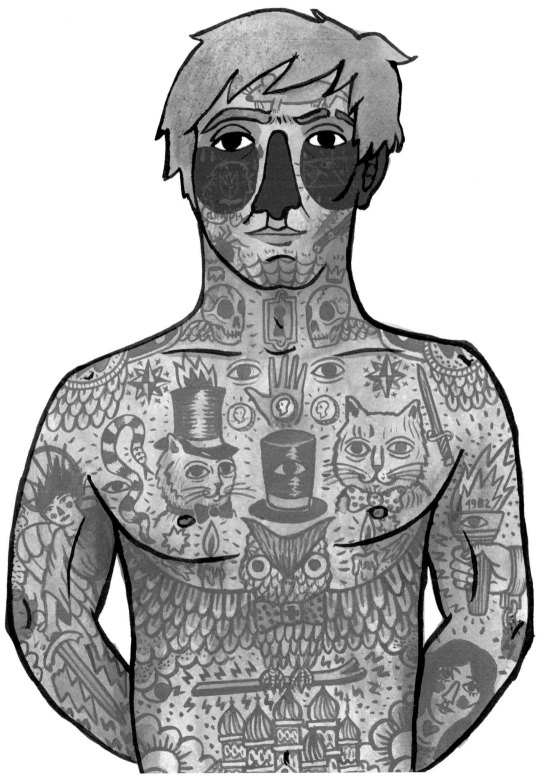

Ivan

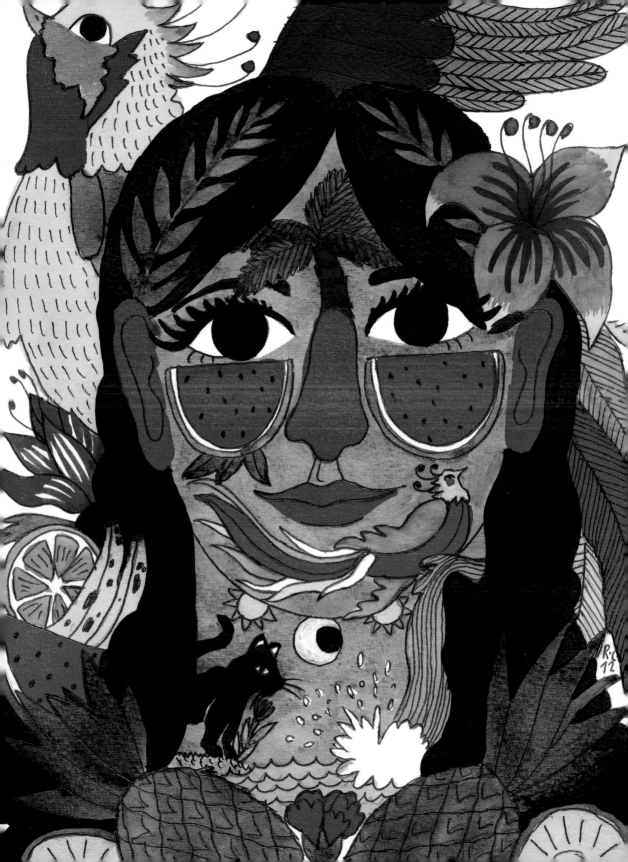

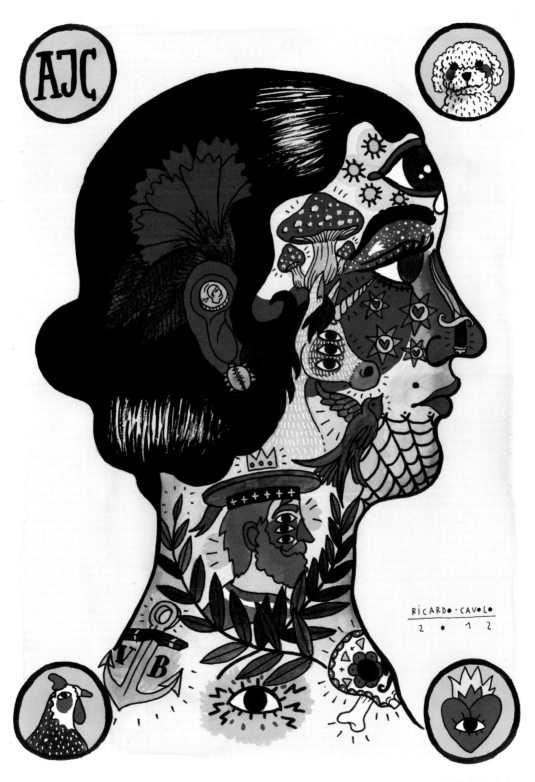

Victoria // **left:** Tropicala

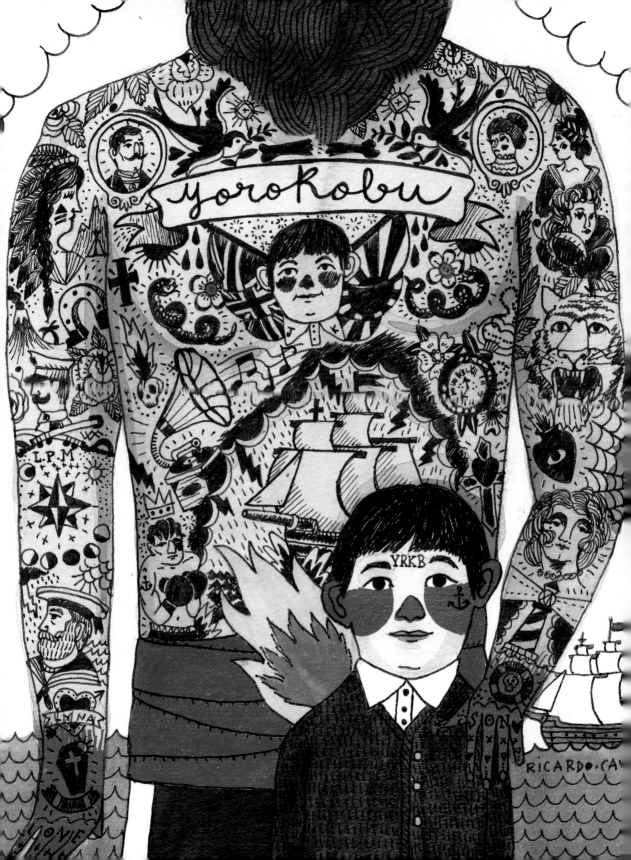

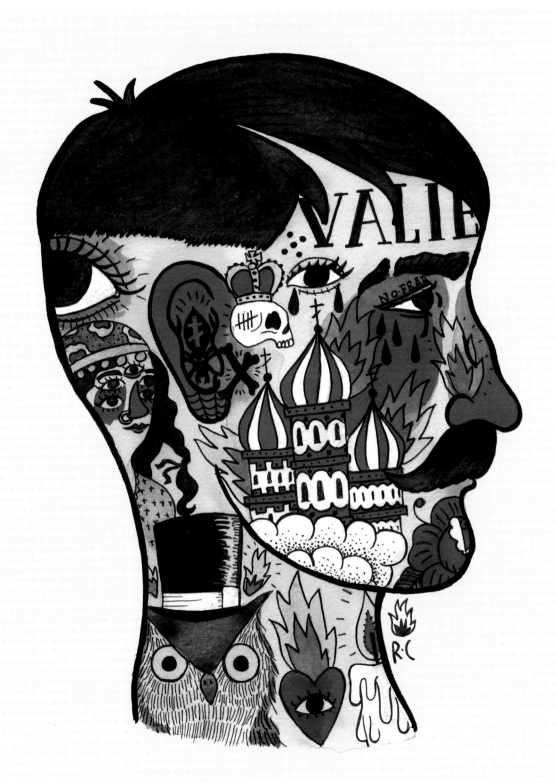

Vlad // **left:** Padre

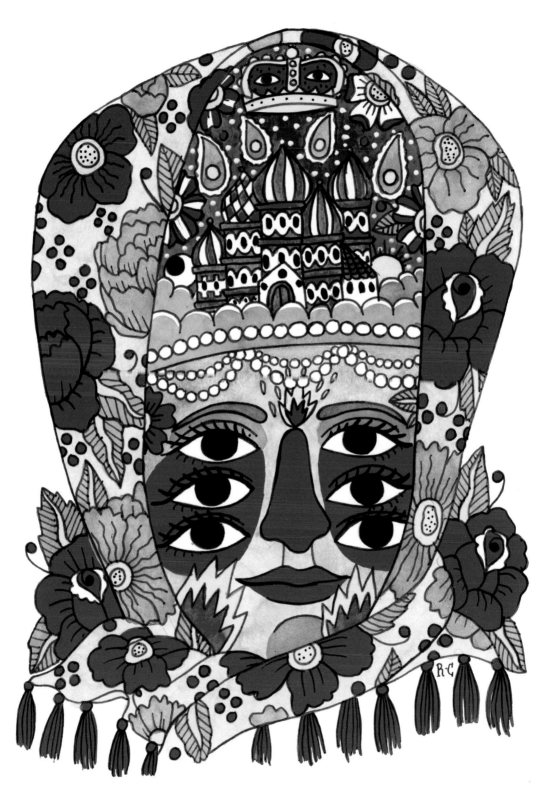

Irina

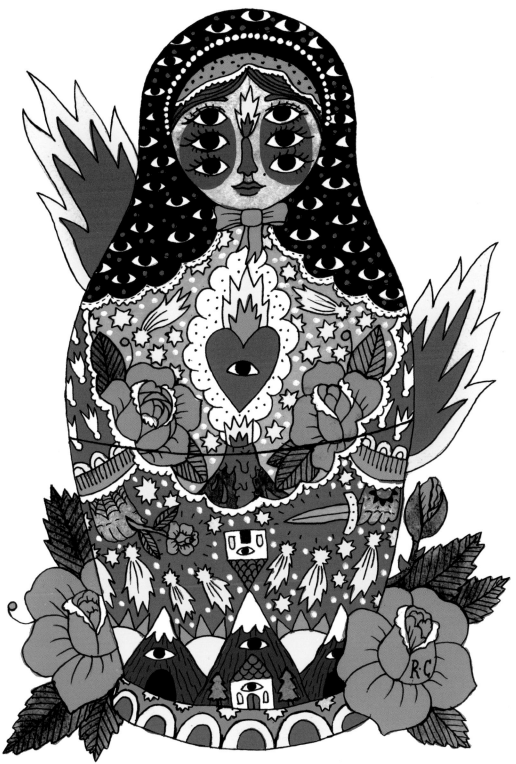

Matrioshka

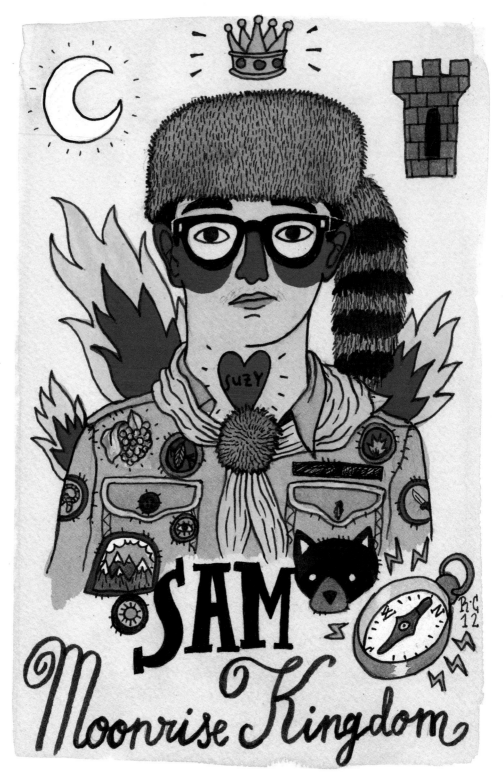

SUZY

SAM

Moonrise Kingdom

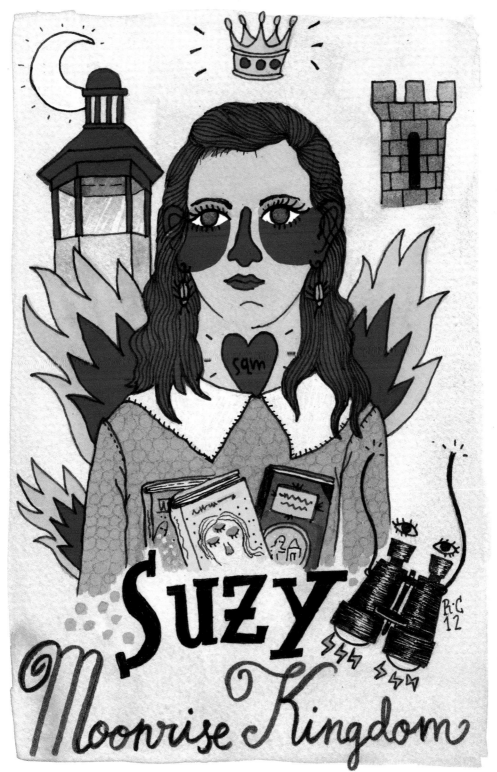

Suzy

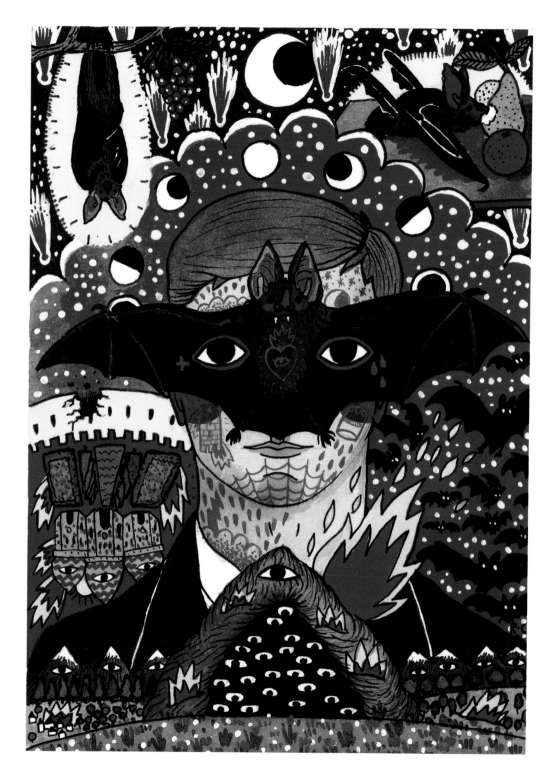

Albert

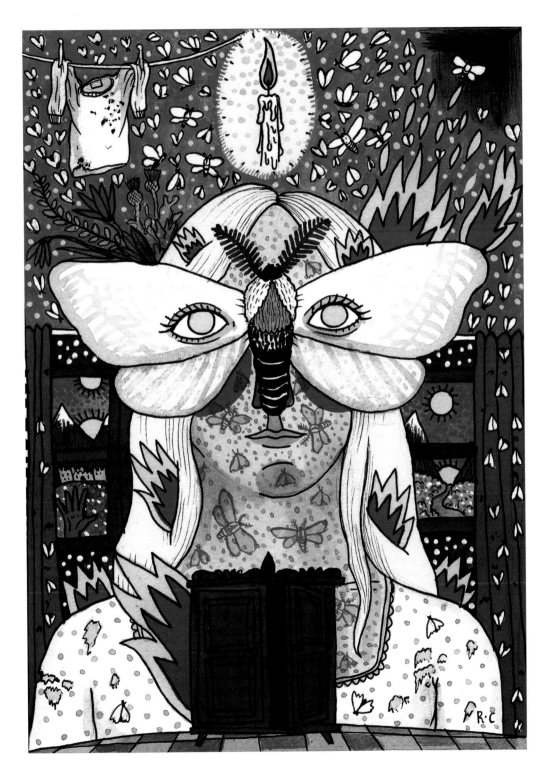

Muriel

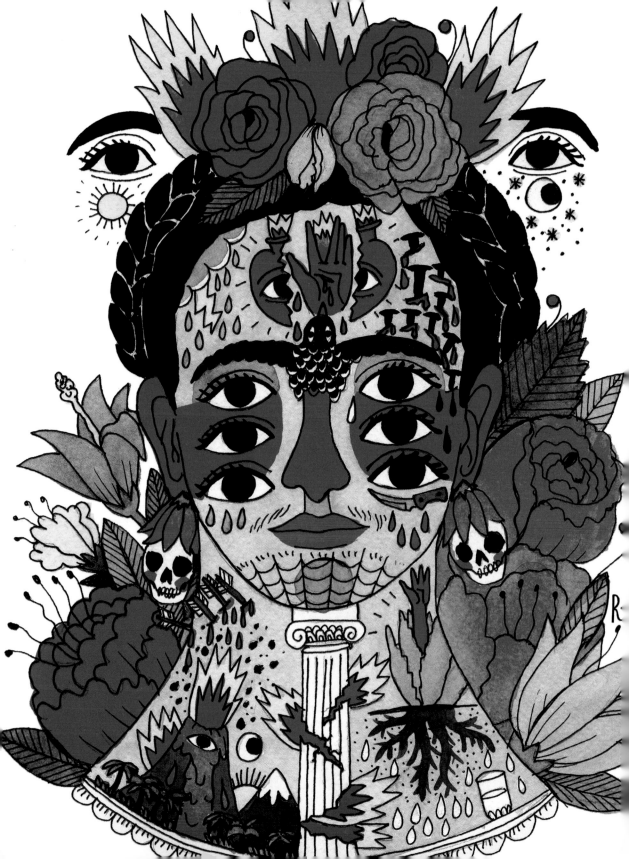

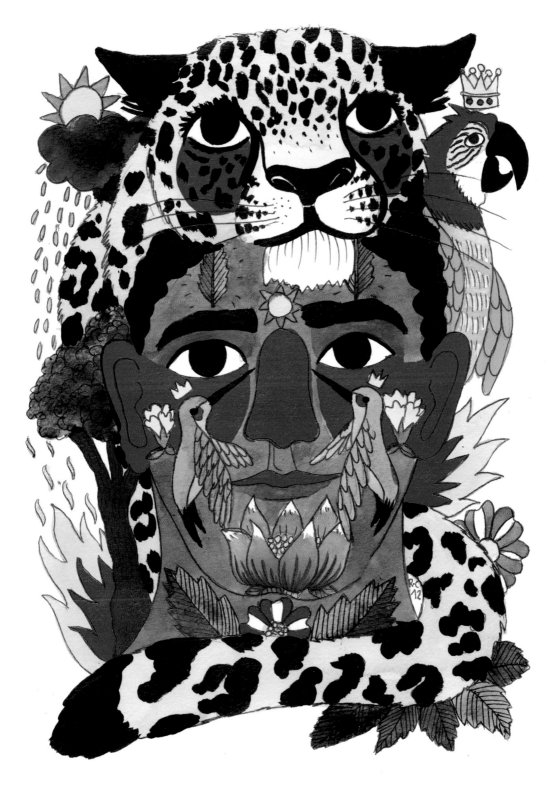

Tropicalo // **left:** Frida

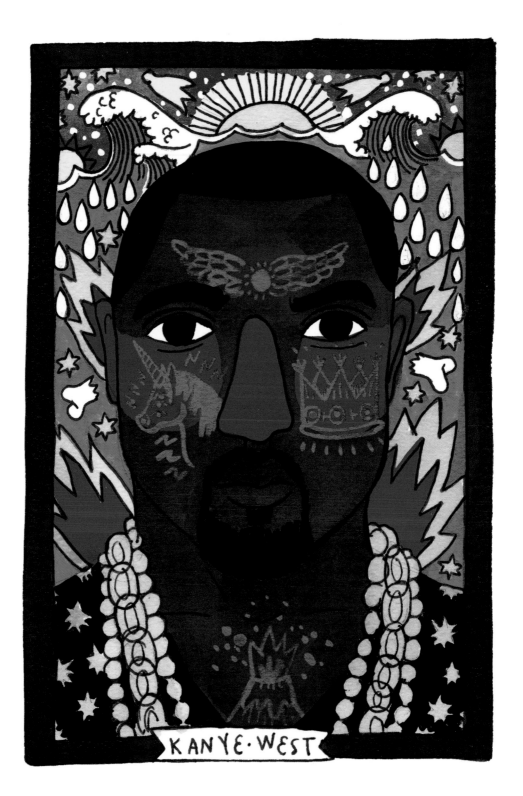

KANYE·WEST

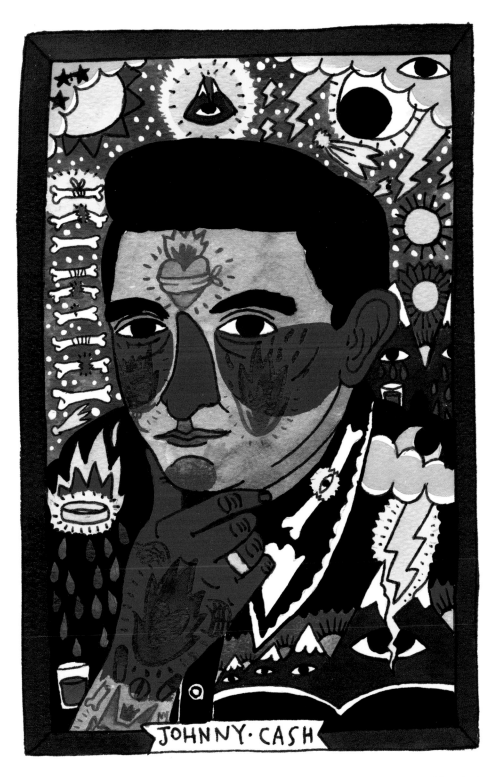

Johnny Cash

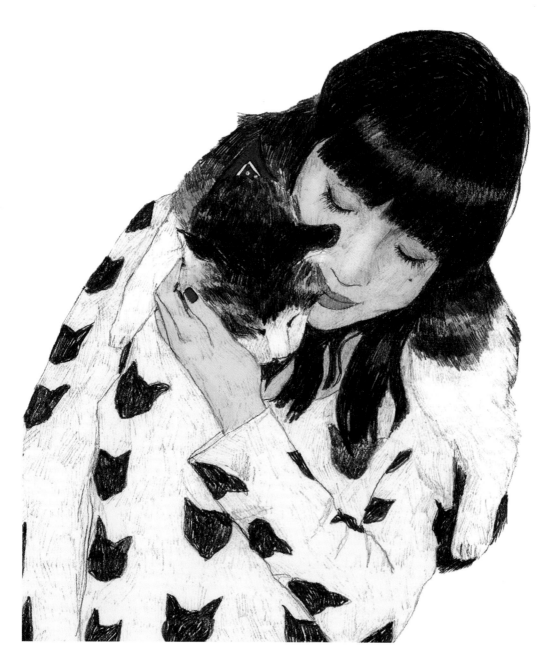

Javiera

DANIELA HENRÍQUEZ

instagram.com/danidahf

Daniela Henríquez was born in Talca – Chile and is 29 years old. Her childhood memories are always marked by her love of painting, colouring and drafting.

She used to pass the whole day colouring; she was always in the company of her notepad and pencils. She devised people, farm animals and houses, filling every notepad with fantasies. She didn't study anything related to design or illustration. She studied pedagogy and later dropped it, because it didn't really moved her.

From the 2010, she has completely dedicated herself to drawing. It always was her way to relax, mainly because she loved doing it as a means to emancipate and share what one loves. Inspiration is a mystery to her, sometimes it comes, others it doesn't. The way she works starts by bumping into an image which attracts her, that almost asks her to be drawn, something that provokes her and then, all this needs to go hand in hand with her mood as she works on completing the idea. She likes to draw animals, her friends, to represent their personal experiences through her drawings.

Daniela Henríquez, nació en Talca – Chile, hace 29 años. Sus recuerdos de la infancia están siempre marcados por su pasión por pintar, colorear y esbozar.

Ella solía pasar todo el día coloreando; siempre acompañada de su bloc y sus lápices.
Ella llenaba sus libretas con personas, animales de granja y casas, plasmaba todas sus fantasías.
Ella no estudió nada relacionado con el diseño o la ilustración. Comenzó los estudios de pedagogía que finalmente no finalizaría, pues no era lo que realmente le apasionaba.

Desde el año 2010 se ha dedicado por completo a dibujar, siempre ha sido su manera de relajarse, principalmente porque le encanta hacerlo, a modo de expresión y de poder compartir lo que ama.
La inspiración para ella es un misterio, a veces le viene a veces no pero, principalmente su modo de trabajo parte por visualizar alguna imagen que le atraiga y que le incite a plasmar en uno de sus trabajos, provocando algo en ella. Le gusta dibujar animales, a sus amigos, y representar sus vivencias personales a través de sus dibujos.

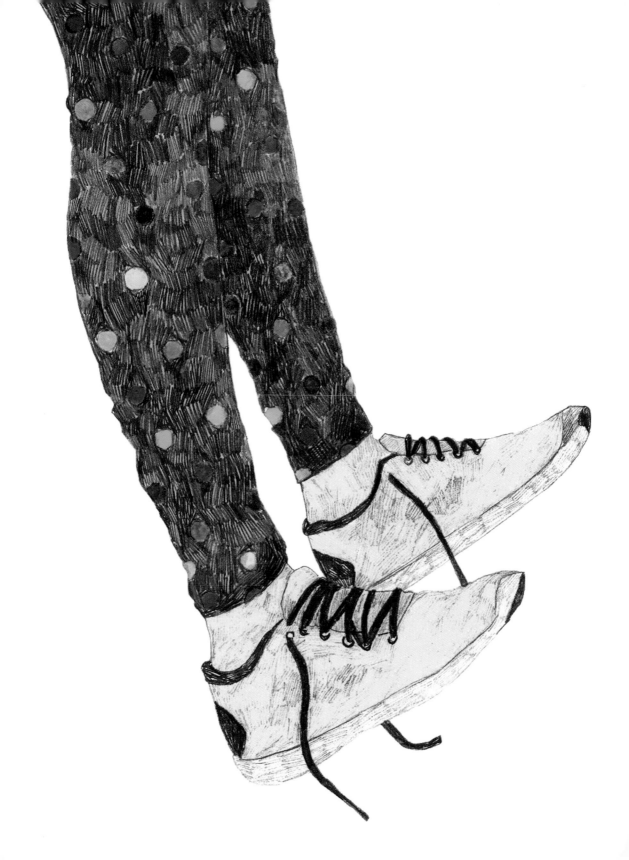

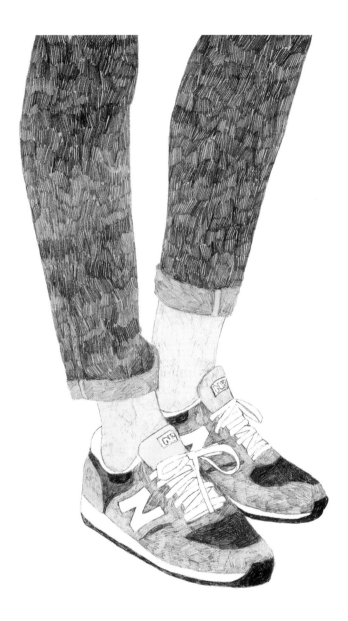

Piernas new balance color // **left:** Piernas lunaticas

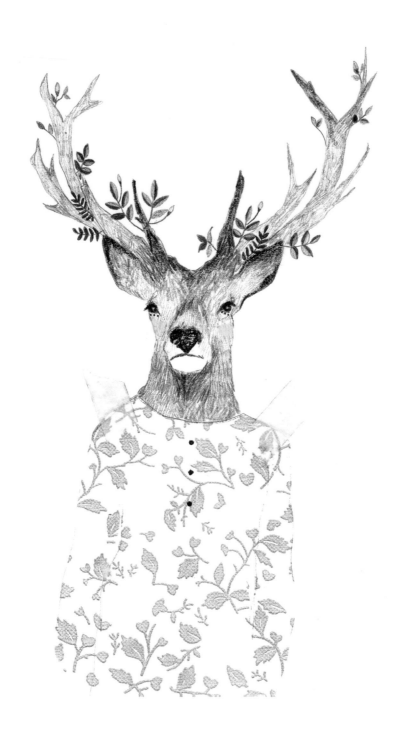

Ciervoarbol

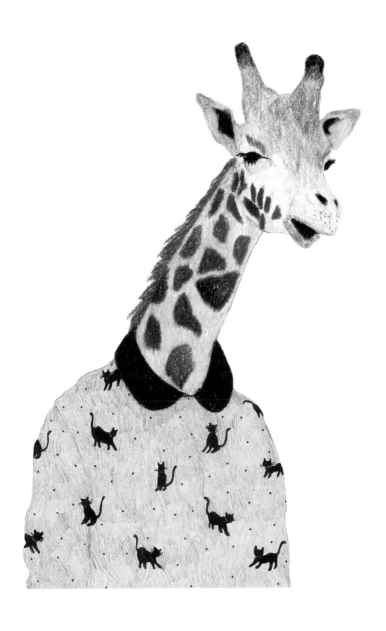

Jirafa

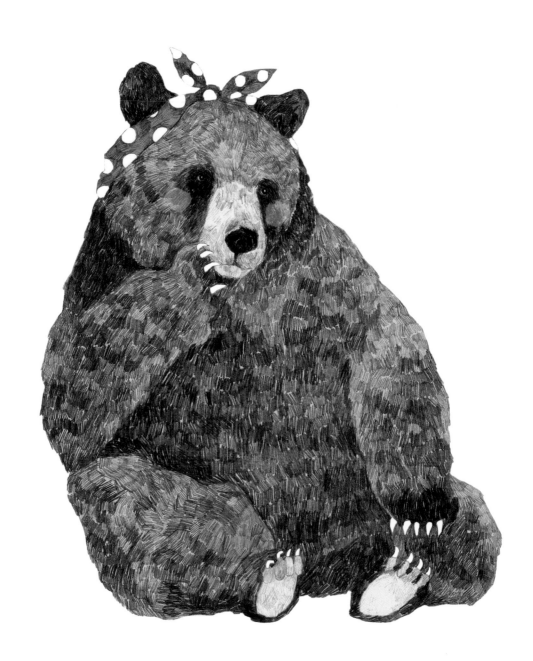

Osa Pinup

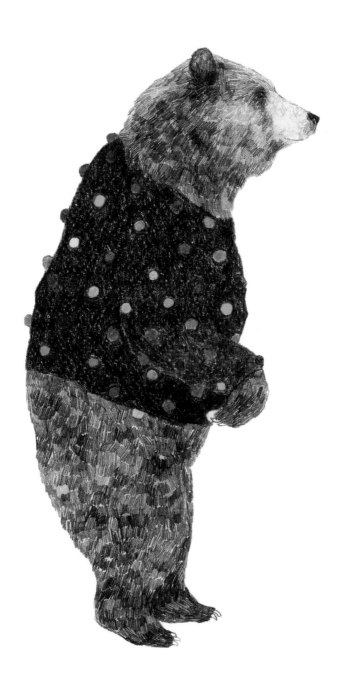

Oso sweter pompom (inspirado en una foto de Nikolai Zinoviev)

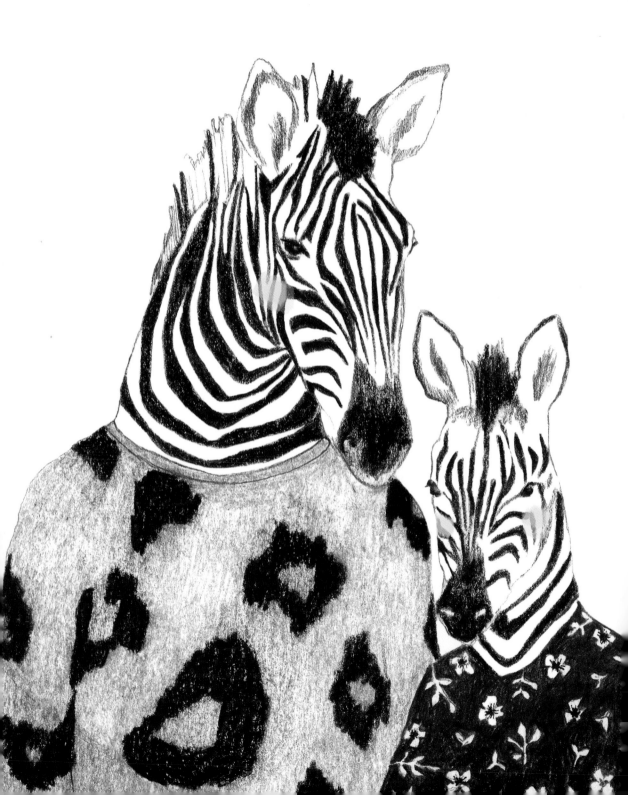

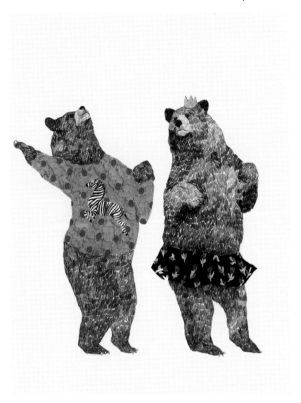

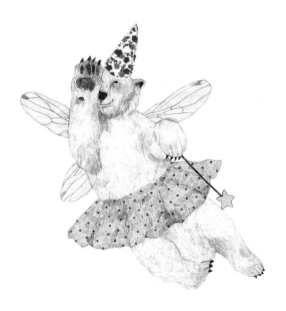

top: Pareja // bottom: Hada de los dientes // left: Family

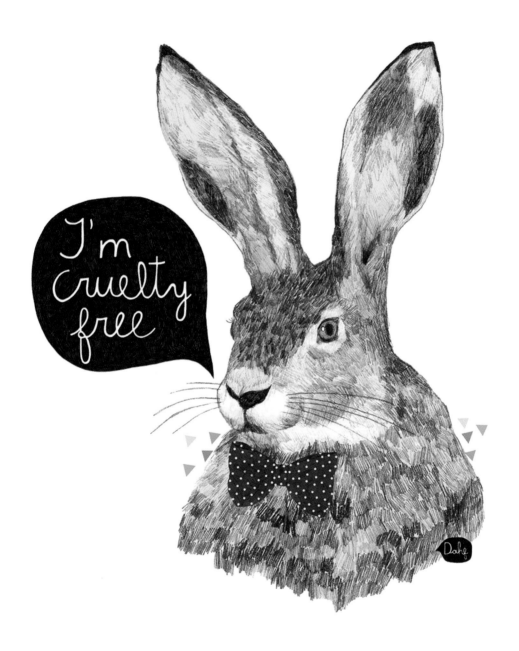

Conejo

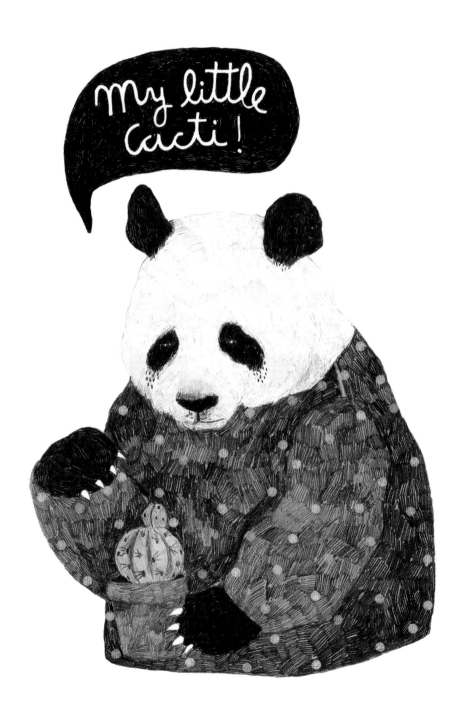

Autorretrato

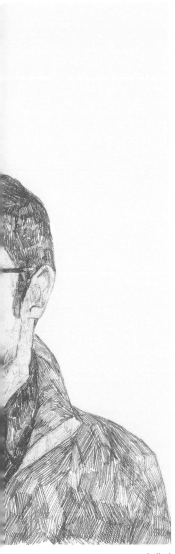

Anibal

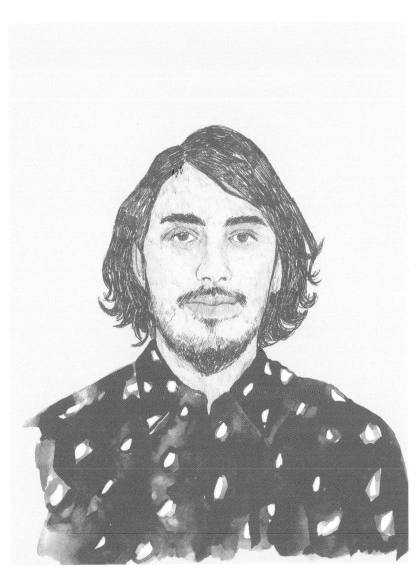

Robin

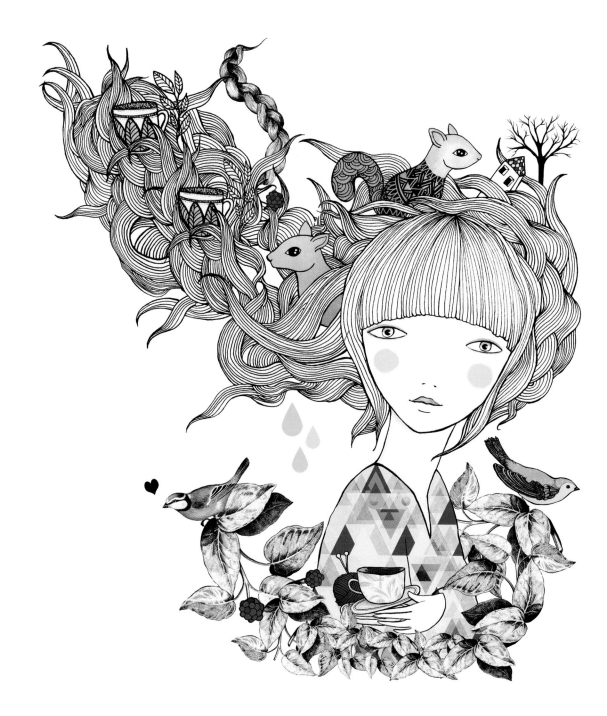

Ardilla

LADY DESIDIA

ladydesidia.blogspot.com.au

Vanessa Borrell signs her illustration works, pattern designs and her own personal signature with the name Lady Desidia since the year 2008. This artist, graduated in Fine Arts, currently lives in Madrid, where she has her study.

During her work process, she enjoys the use of traditional technics such as watercolour, ink and graphite lead that she later combines with digital technics. Her inspiration comes from the daily and the familiar, botany and childhood memories and emotions.

Vanessa Borrell firma sus trabajos de ilustración, diseño de estampados y su propia firma con el nombre de Lady Desidia desde el año 2008. Esta artista licenciada en Bellas Artes vive actualmente en Madrid, donde tiene su estudio.

En su proceso de trabajo disfruta con el uso de técnicas tradicionales como las acuarelas, tintas y grafito, que combina posteriormente con técnicas digitales. Su inspiración viene de las cosas cercanas y cotidianas, de la botánica, y de los recuerdos y emociones de la infancia.

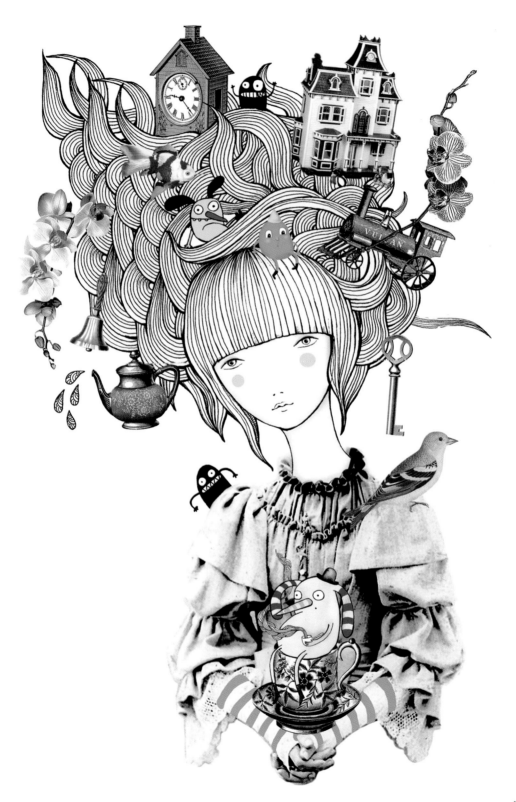

Enredada

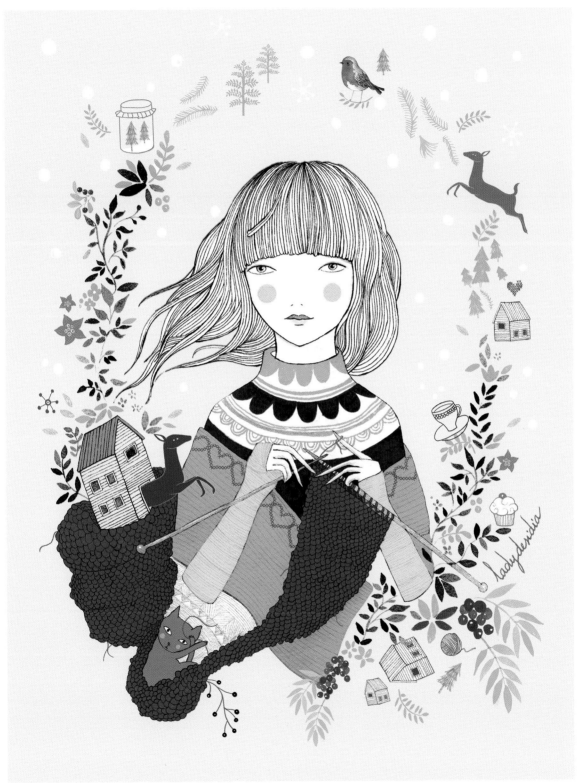

Knit

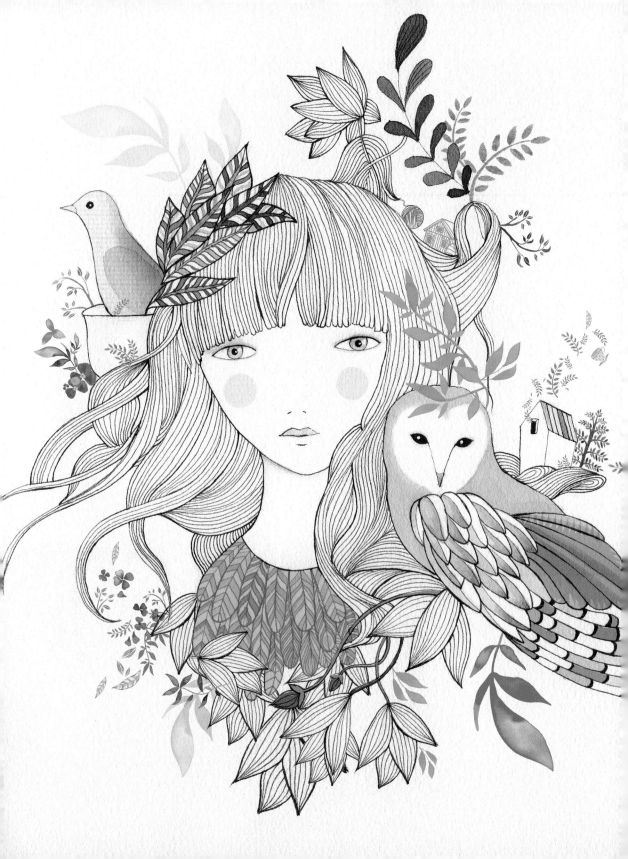

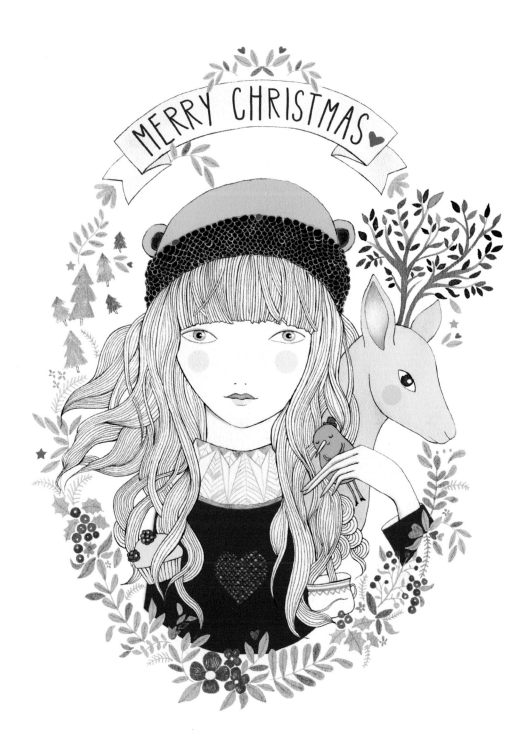

MERRY CHRISTMAS

Merry // **left:** Lechuza

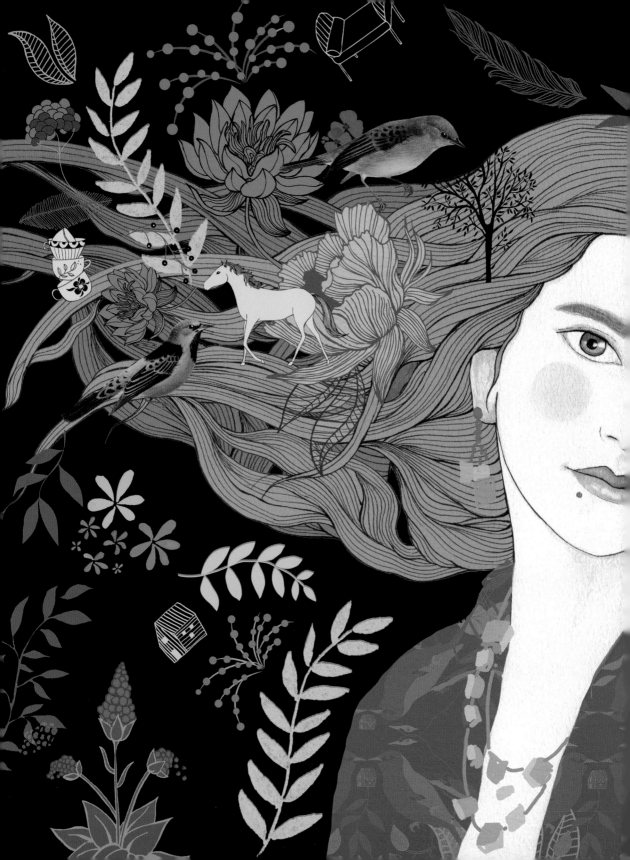

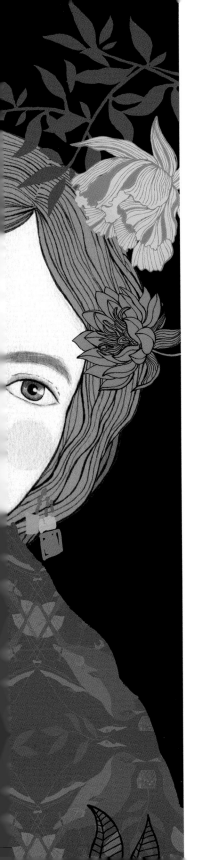

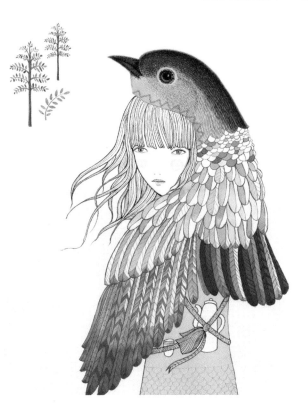

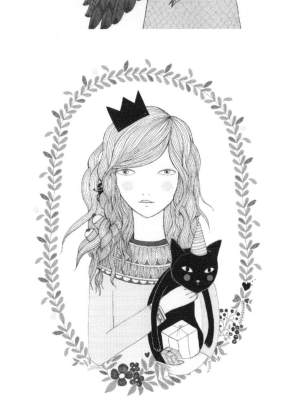

top: Bird // **bottom:** Cat // **left:** Marta Gómez

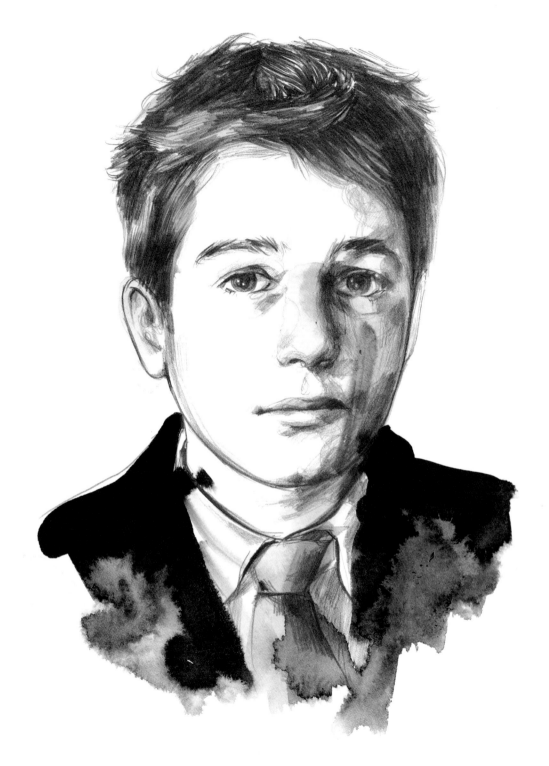

Antoine Doinel (from book "813")

PAULA BONET

paulabonet.wordpress.com

Vila-real, 1980

Fine Arts B.A. from the Polytechnic University of Valencia, she completes her education in Santiago de Chile, New York and Urbino. She initially worked with oil and engraving (chalcographic, xylographic, lithographic), but from 2009 onwards she focuses on illustration and would work in that field until 2015. Currently, she combines both disciplines.

In 2013 she illustrated "Léeme" -Read Me- (Andana Editioral) and the Estel Solé's poem book "Si uneixes tots els punts" –If You Joined All the Dots- (Editorial Galerada). "Qué hacer cuando en la pantalle aparece The End" – What to do When the Screen Shows The End- (March 2014, Lunwerg Editorial). On September 2014 she publishes "La pequeña Amelia se hace mayor" –Little Amelia Grows Up-, an illustrated pop up album (Editorial Combel). "813" is the second book for which she authorises both text and images. It consists on an illustrated homage to the French film maker François Truffaut and a fragment of his filmography (La Galera, February 2015).

Her production has been exhibited in Barcelona, Madrid, Valencia, Oporto, Paris, London, Belgium, Urbino and Berlin.

Her work, filled with poetry, has manifold ramifications, from illustrations for the press (Yorokubu, Diari Ara, Revista Kireei, Revista Calle 20, Ling, ESCAC, Caràcters, Le Cool) to scenography, posters (Keys, Vetusta Morla, Jacko Hooper, Christina Rosenvinge) or mural paintings.

Vila-real, 1980

Licenciada en Bellas Artes por la Universidad Politécnica de Valencia, completa su formación en Santiago de Chile, Nueva York y Urbino. Inicialmente trabajó las técnicas de pintura al óleo y grabado (calcográfico, xilográfico, litográfico), pero a partir de 2009 se centrará en la ilustración y hasta 2015 trabajará en ese campo. Actualmente combina ambas disciplinas.

En 2013 ilustra "Léeme" (Andana Editorial) y el poemario de Estel Solé "Si uneixes tots els punts" (Editorial Galerada). "Qué hacer cuando en la pantalla aparece The End" es el primer libro con texto e ilustraciones de su autoría (marzo de 2014, Lunwerg Editorial). En septiembre de 2014 publica "La pequeña Amelia se hace mayor", un álbum ilustrado pop up (Editorial Combel). "813" es el segundo libro del que es autora tanto del texto como de la imagen, se trata de un homenaje ilustrado al cineasta francés François Truffaut y a un fragmento de su filmografía (La Galera, febrero 2015).

Su obra ha sido expuesta en Barcelona, Madrid, Valencia, Oporto, París, Londres, Bélgica, Urbino y Berlín.

Su trabajo, cargado de poesía, tiene multitud de ramificaciones, desde la ilustración en prensa (Yorokobu, Diari Ara, Revista Kireei, Revista Calle 20, Ling, ESCAC, Caràcters, Le Cool), la escenografía, el cartelismo (The Black Keys, Vetusta Morla, Jacko Hooper, Christina Rosenvinge) o la pintural mural.

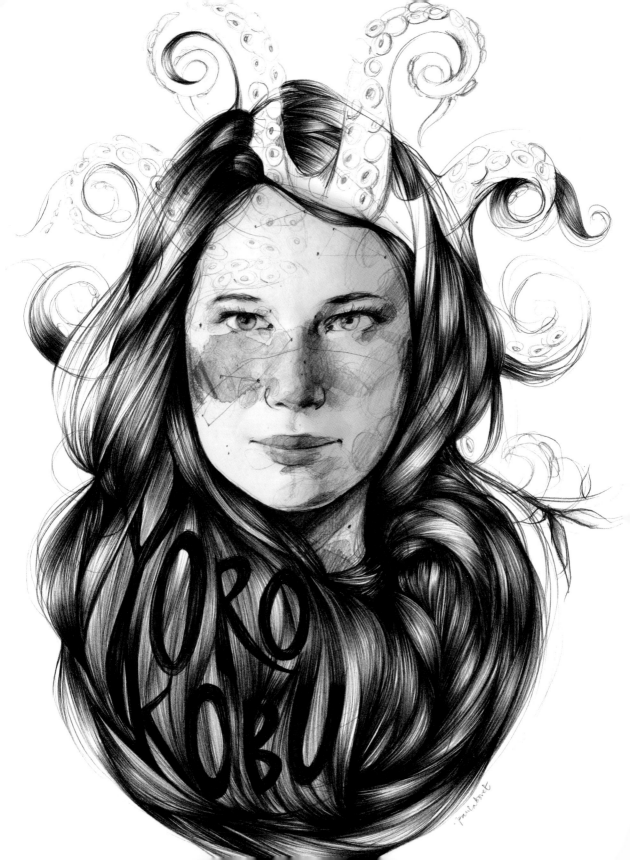

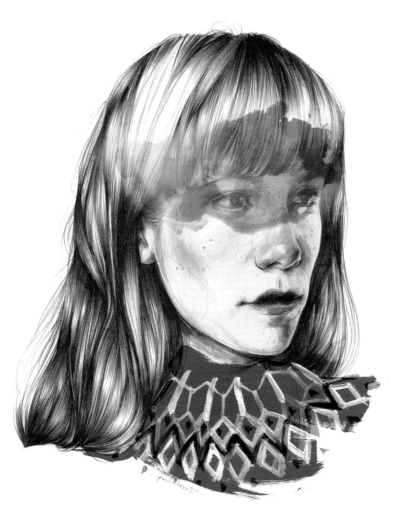

-I feel blue. But not for so long

Blue // **left:** Yorokobu// **next page:** La tejedora (for "Lo Nuestro" of Christina Rosenvinge)

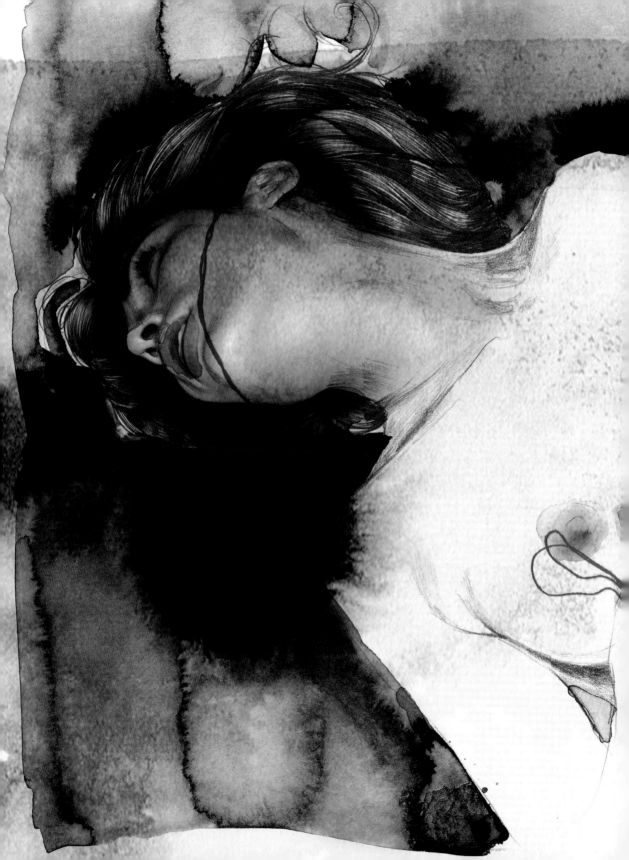

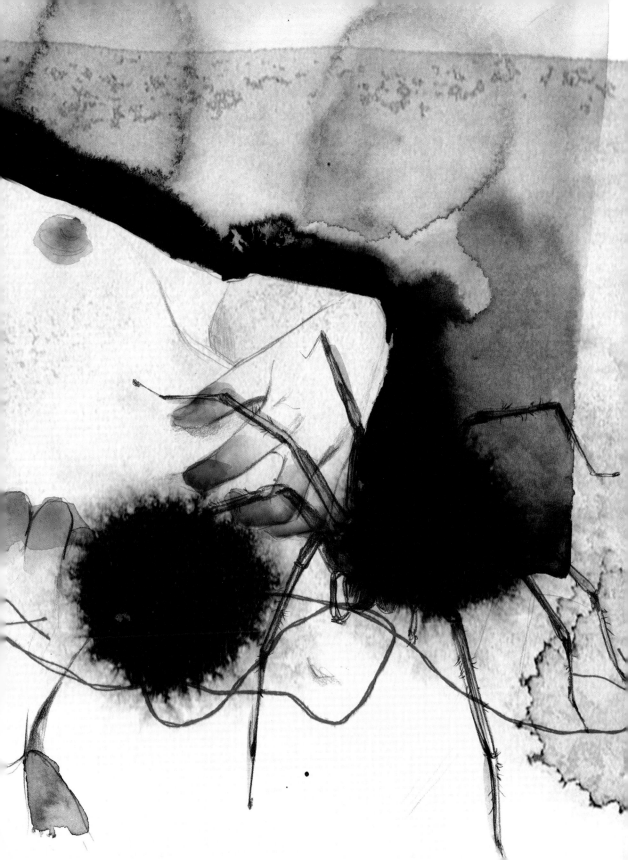

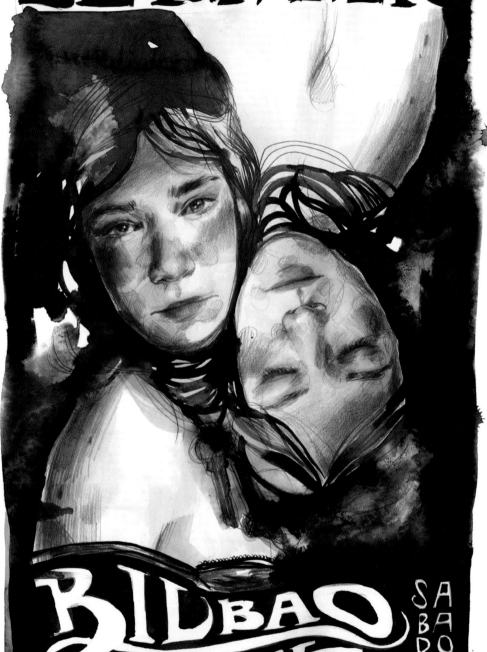

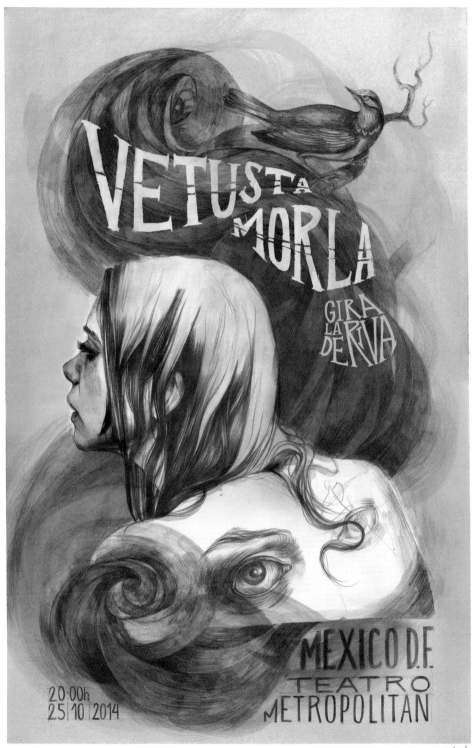

Vetusta Morla // **left:** The Black Keys

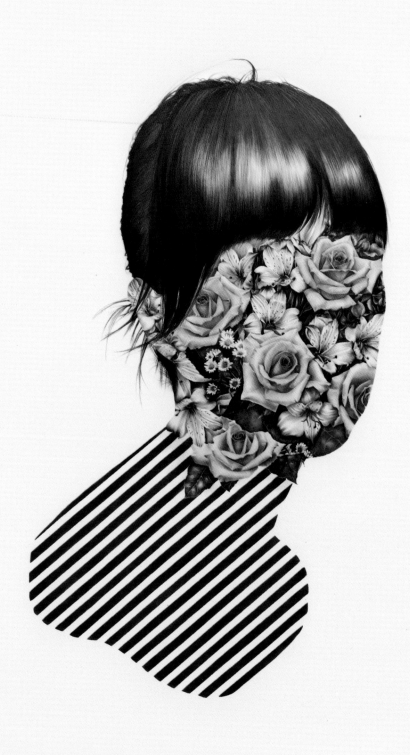

Face First, 2012

LANGDON GRAVES

cargocollective.com/langdongraves

TEXT BY **RUSS CREST, BEAUTIFUL/DECAY**

Langdon is a Virginia-born, Brooklyn, NY-based artist who received her BFA from Virginia Commonwealth University and her MFA from Parsons in New York City in 2007. Langdon's work has been shown throughout the United States, Europe and Australia and has appeared in Art News, the New York Times, Juxtapoz, High Fructose, Beautiful Decay and Gestalten. She has attended the Fountainhead Residency in Miami and participated in The Kunstenaarsinitiatief Residency and Exhibition program in the Netherlands, and is a recipient of Canson and Beautiful Decay's Wet Paint Grant.

"Langdon Graves is all about the mystery of deception and illumination. Her drawings utilize two contradicting devices, photo-realistic rendering and surrealist narrative, all to create trompe l'oeil images that astound and leave you wanting more. Each drawing has elements that are immediately recognizable, but the second you think you know what is going on, you realize something is amiss. There is a delicate sense of instability that disrupts the calm in each drawing."

http://beautifuldecay.com/2011/10/04/wet-paint-grant-recipient-langdon-graves/

Langdon es una artista nacida en Virginia que vive en Brooklyn, Nueva York. Se licenció en Bellas Artes en la Universidad de la Commonwealth de Virginia y se sacó el máster en Bellas Artes en Parsons, en la ciudad de Nueva York, en 2007. Las obras de Langdon se han exhibido en todo Estados Unidos, Europa y Australia, y han aparecido en Art News, The New York Times, Juxtapoz, Hi-Fructose, Beautiful/Decay y Gestalten. Ha asistido a la Fountainhead Residency de Miami, ha participado en el programa de exposición de la Kunstenaarsinitiatief Residency de los Países Bajos y le han otorgado el Wet Paint Grant de Canson y Beautiful/Decay.

«Langdon Graves es el misterio del engaño y la iluminación. Sus pinturas utilizan dos recursos contradictorios —una presentación fotorrealista y una narrativa surrealista— para crear trampantojos que te dejan asombrado y con ganas de más. Todos sus cuadros contienen elementos inmediatamente reconocibles pero, en el momento que crees que sabes qué es, te das cuenta de que algo pasa. En todas sus pinturas, hay un sentido delicado de inestabilidad que perturba la calma».

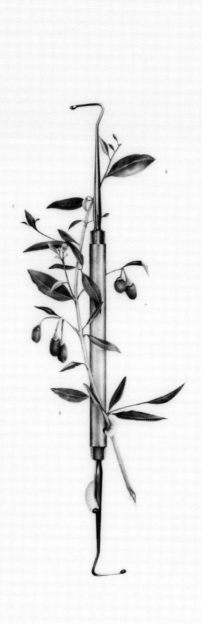

Asclepius, 2013 // **left:** Astigmatic, 2011

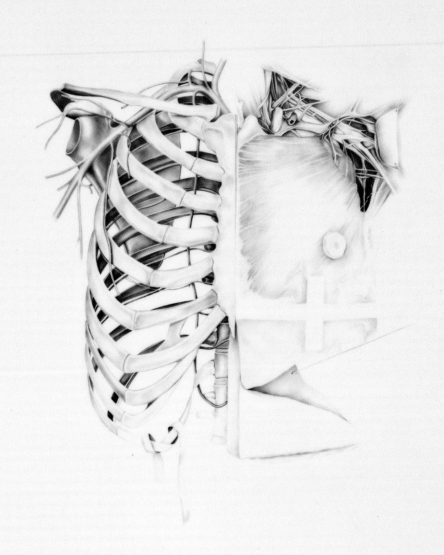

Earth & Water, 2013

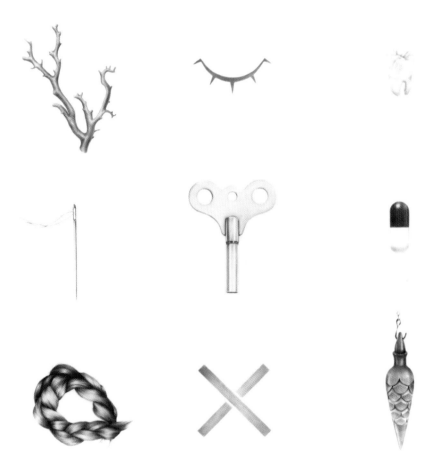

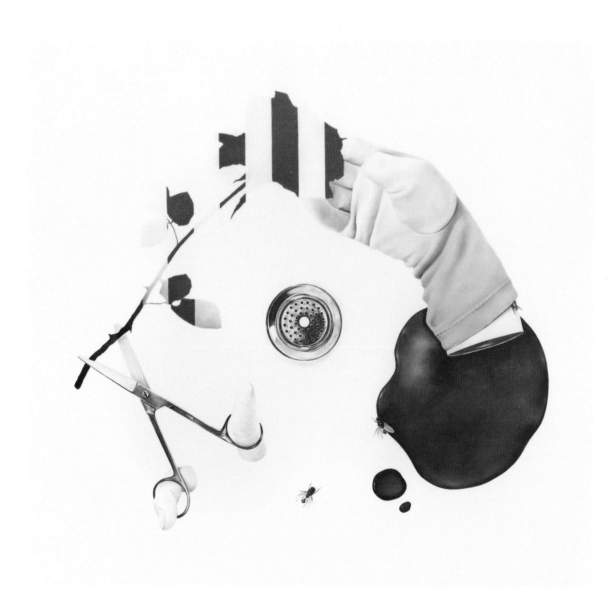

Small Truth, 2013

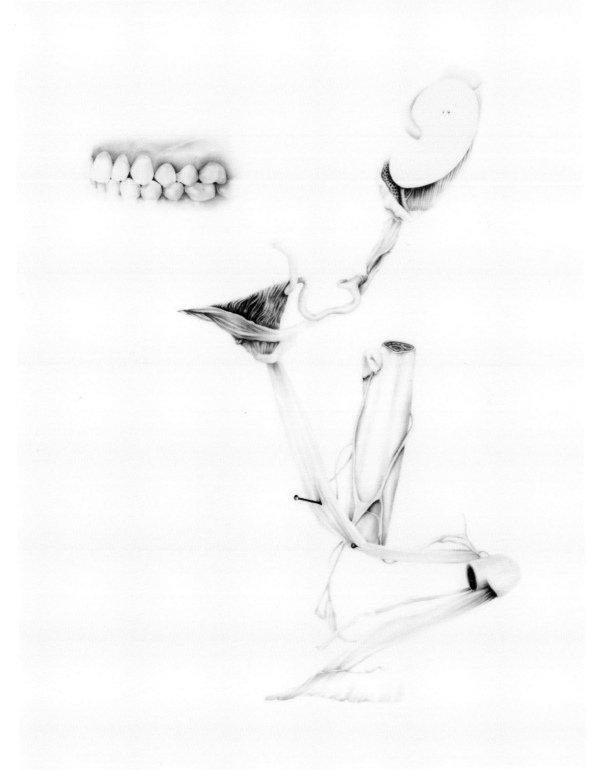

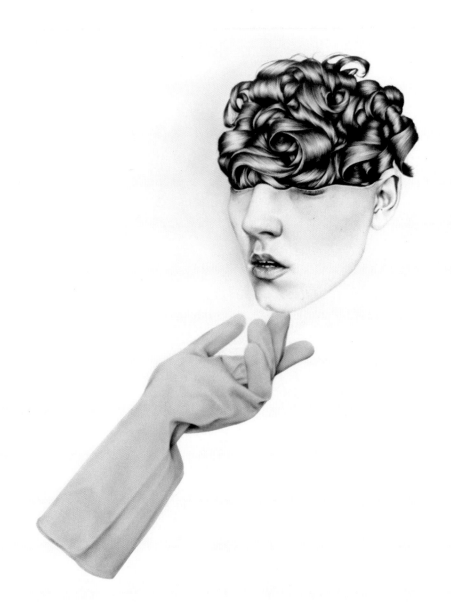

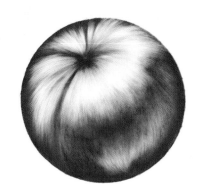

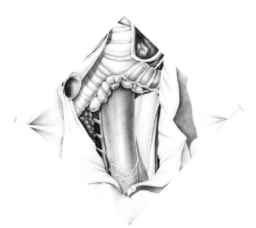

Restricted in Her Ability to Maneuver, 2013

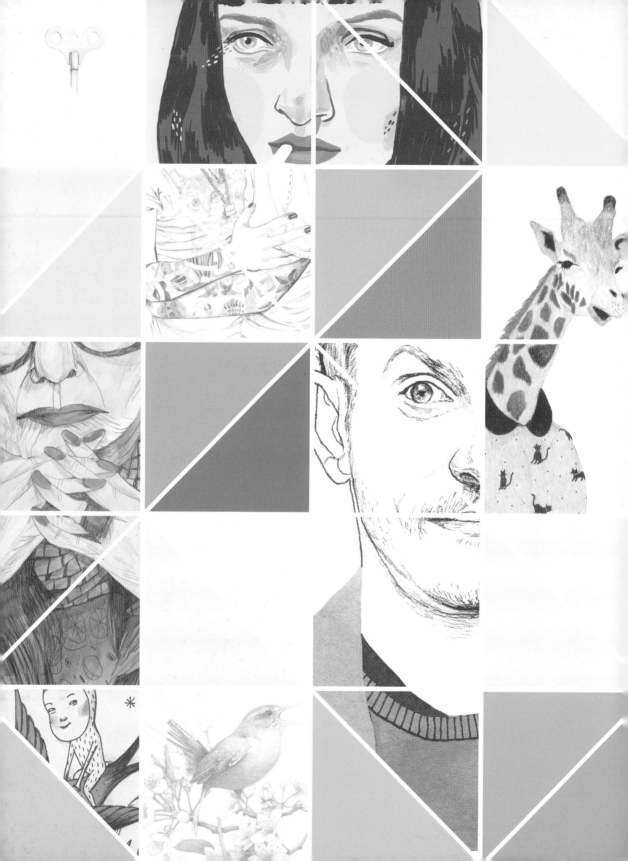